Landscape Meditations

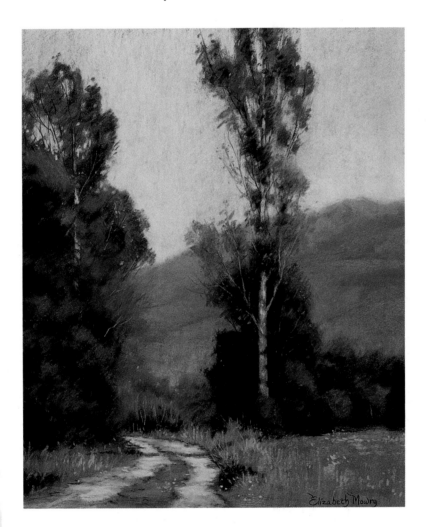

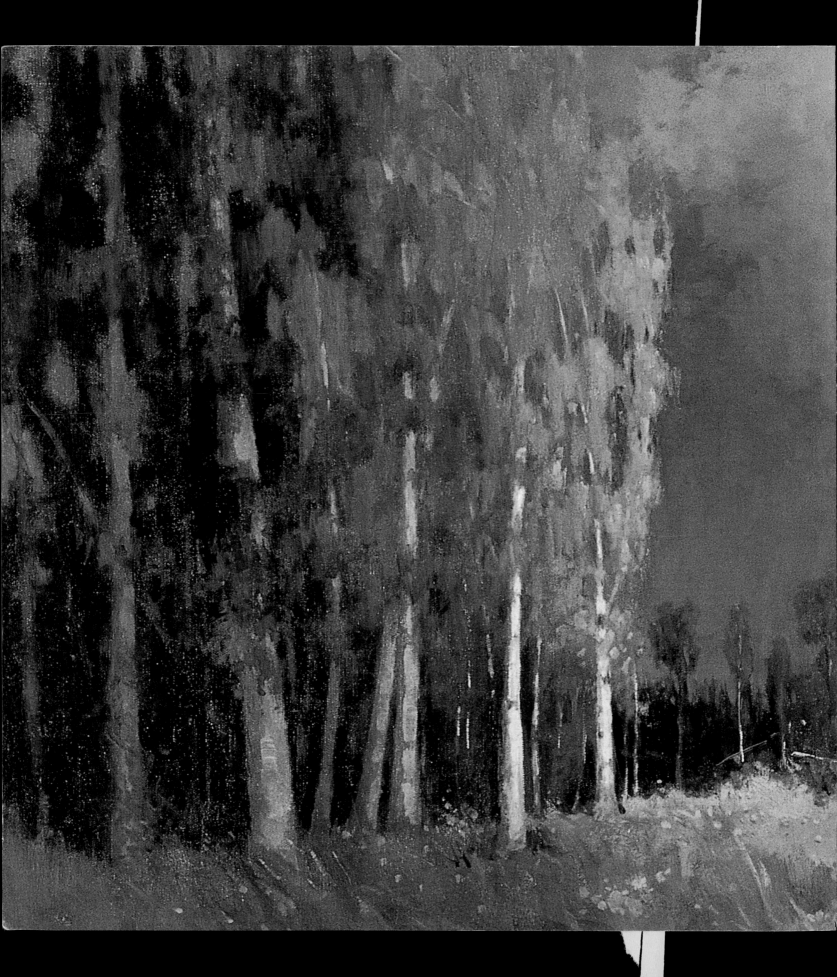

Landscape Meditations

AN ARTIST'S GUIDE TO EXPLORING THEMES IN LANDSCAPE PAINTING

ELIZABETH MOWRY

WATSON-GUPTILL PUBLICATIONS
NEW YORK

FRONTISPIECE: GUARDIANS, pastel on pastel card, 16 1/2" × 13 1/2", 2004, collection of Jennifer and Antony Hayward

TITLE PAGE: HAY DAY ON THE EDGE (DETAIL), oil on canvas, 30" × 40", 2004

PAGE 6: SOFTLY DAWN, oil on canvas, 12" × 12", 2004, private collection

PAGES 28–29: MEADOWS AND WILDFLOWERS (DETAIL), pastel on mounted sanded paper, 20" × 36", 2000, collection of Ginger and Les Tronzo

PAGES 50–51: WHERE WILD THYME GROWS (DETAIL), pastel on mounted sanded paper, 14" × 22", 2003, collection of Ginger and Les Tronzo

PAGES 68–69: LOOKOUT, NORMANDY (DETAIL), pastel on sanded paper, 12" × 20", 2002

PAGES 80–81: KAFKA'S DREAM (DETAIL), oil on canvas, 18" × 24", 2004

PAGES 94–95: HORIZONTALS AND VERTICALS (DETAIL), pastel on pastel card, 12" × 20", 1998, private collection

PAGES 108–109: THE FIELD U (DETAIL), pastel on mounted sanded paper, 16" × 46", 2001, collection of Betty and David Wall

PAGES 124–125: BECKONING V (DETAIL), pastel on pastel card, 12" × 18", 2003

PAGES 132–133: MORNING PATTERNS (DETAIL), pastel on pastel card, 7" × 15", 1996, private collection

PAGES 138–139: THE ORCHARD, SPRINGTIME (DETAIL), pastel on panel, 12" × 16", 1996

PAGES 146–147: VERONICA'S LACE 2 (DETAIL), pastel on board, 16" × 20", 1999, collection of Kit and Gordon Taylor

First published in the United States in 2005 by
Watson-Guptill Publications
Crown Publishing Group, a division of Random House Inc., New York
www.crownpublishing.com
www.watsonguptill.com

Acquisitions Editor: Candace Raney
Editor: Meryl Greenblatt
Designer: Areta Buk/Thumb Print
Production Manager: Ellen Greene

Library of Congress Control Number: 2004115338

ISBN: 0-8230-2602-7

Printed in Singapore

First printing, 2005

6 7 8 9 / 13 12 11 10

Acknowledgments

With deepest gratitude to Martha, HongNian, Deane, Eva, Sylvie, Claire, Annemie, Sonny, Kate, Christine, Olaf, Kaete, Dominique, Georgette, Jim, and Michael, for those infrequent but memorable end-of-day conversations (when our light was gone, of course) about what is important and what is probably not, and about embracing the ecstasy of the first with reverence, and dismissing the agony of the other with an infectious and necessary sense of humor.

To Phyllis, for enthusiasm matched only by her determination to keep up with the French drivers on precariously curving roads that led us ultimately to all of the lavender fields in southeastern France. Thank you, dear friend.

Thanks to Jason Zhang, my computer "hero," for dissolving the mysteries of technology with lightning expertise and a patient smile.

Thanks to Andy Wainwright for same- or next-day, excellent quality slides, and for impeccable advice, sometimes unheeded.

With gratitude to the people who have allowed me to share excerpts from their correspondence to me having to do with my artwork and writing.

Finally, once again I am deeply indebted to the Watson-Guptill Staff: Candace Raney, acquisitions editor, for her interest, guidance, and encouragement during and between my book adventures with Watson-Guptill; editor Meryl Greenblatt, for professional expertise filtered through her own artistic eye while working tirelessly to preserve my vision for the outcome of this book; art designer Areta Buk, for her unique ability to match the artwork and the words into a seamless design that poignantly represents the essence of the artist; and, once again, Ellen Greene, a most conscientious production manager with high standards who knows what doing the best means and then gives generously of her time to attain that end without compromise. Thank you all.

Again, to my loved ones:

As years unfold

You have whispered the dust from my wings

That I might fly . . .

Yet softly, wordlessly, you are there,

I know, should I fall.

My heart overflows with gratitude.

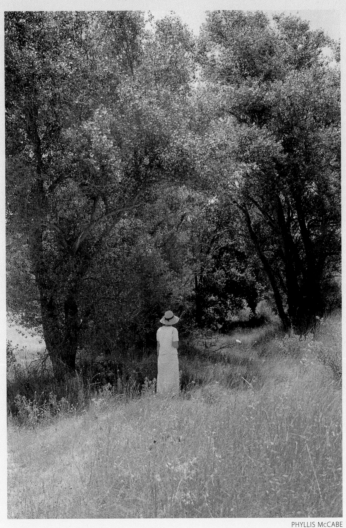

PHYLLIS McCABE

Contents

Introduction

SAME-SUBJECT LANDSCAPE painting is fueled by persistent emotional attachment to a place or an idea. Ultimately, it becomes the artist's visual dissertation. When a wistful fascination with a few landscape components escalates into a passionate obsession, theme painting is comparable to falling in love. Once it takes hold, it affects the way we perceive everything else. We want and need to learn all there is to know about it. Everything is viewed with respect to how it relates to our "fixation." Meaning tumbles from book titles, passages of music, world events, and even the most mundane daily activities. During the time I painted "The Field" (see Chapter 6), the flattened swaths of meadow grasses after a downpour came to mind as I ironed clothes. Pulling weeds reminded me to remove distracting detail from a painted foreground. The mind will attempt to engage all that it can into the fabric of the story that stumbles through our inner landscape in its struggle to emerge. The extended hand of our muse beckons . . . and beckons again.

Above all, series painting has to do with finding the essence of a place or an idea. Once a motif is selected (or we are selected by it), the process has more to do with being open to the ideas that flow rather than grasping for them. It also has more to do with giving our *best* to what we do, than to want something to happen *because* of what we do.

After developing the skills and techniques necessary for expression, an artist's quest shifts to finding a worthwhile concept: a critical prerequisite of a good painting is a good idea. Concepts have enormous impact on the outcome of our work and are responsible for whether or not paintings will resonate with those who view them. Artistic vision comes from within, and over time. It is not something we acquire from anyone else. The formation of concepts falls into that same elusive category. Concepts take shape in our consciousness when other criteria are in place. Certain things we pursue by learning and practice. Others we wait for, quietly, quite often alone. The key is to acknowledge the difference. It is the concept that needs to be unequivocally clear; the actual details of a place do not. With the concept in place, it is not necessary to struggle in order to move forward. We get started and then calmly become aware of the direction and follow. Nothing is forced.

The concept for a series of landscape paintings may exist within a wide range of possibilities. We might experience the irresistible pull of a compelling place (as in Chapters 6, "Exploration of Place," and 10, "Visual Narration in a Series"). At other times, a landscape motif persists relentlessly and begins to be unconsciously reflected in much of our work as an ongoing theme (see Chapter 2, "Ongoing Themes"). We may not even be aware of recurring patterns at first. Then one day, as we look at a collection of our own work, we simply think, "Oh, yes, of course." Real learning comes quietly, unannounced, and without a parade.

We ask ourselves, "Is this subject worthy of painting, or is it simply an exercise in technique about something that happens to be in front of me?" While the same idea may be entertained by many people concurrently,

CHORUS LINE
Pastel on sanded paper, 10" × 24", 1999

honest expression of it will reflect personal translations. Therefore, when one uses an idea already expressed by others, it becomes unequivocally necessary to find a way to take the idea deeper, further, or in a different direction to avoid finding oneself on an inevitably dead-ended plateau with unfulfilling work that echoes refrains from someone else's song. It is impossible for anyone to travel the emotional terrain of another.

Empty spaces will be filled, though differently for all people. But is it possible for an idea to find space in a brain or a life that is overloaded already? Some years ago I read a book—still a favorite—called "Meditations," by Thomas Moore. Essentially it was about the answers that must be found within *ourselves*, because that is where they are. It addressed the questions . . . the big questions we ask ourselves when we are quiet. Isolation, when embraced, unlatches the door to all kinds of self-knowledge, which in turn manifests itself in our

personal approach to living, and to painting as well. Some people believe that they always need a teacher or a guru to show them the way; eventually they may become paralyzed by dependence. A good teacher will set the students free as soon as they have learned what can be taught, keeping in mind that some things cannot be given or taken but must be experienced firsthand. In painting, such insights are responsible for the difference between average work and the exceptional.

Dictionaries define "meditation" with phrases that include the following: "revolving in one's mind"; "contemplating deeply and continuously"; "pondering"; and "solemnly reflecting." Many of these definitions are tossed about indiscriminately, usually with a market in mind that is chasing after spiritual shortcuts. Landscape paintings as meditations imply staying with and striving to understand even a small part of nature.

This comes with giving it space on our painting surface and in our mind . . . and then more space and even more, always pressing the edge. If we paint the same motif over and over and do not learn anything, we are repeating. When we *thoughtfully* paint a motif again and again, our understanding of it will expand and learning will occur as the psychological and physical landscapes merge. "Before this happens, it is a big thing. Once we know it, it is nothing" (based on informal talks given by Zen master Shunryu Suzuki).

Like a melody of a song that lingers at the periphery of our thoughts as we go about our everyday tasks, visual components of a place can pull and tug at the artist ever so subtly. Then like a snowball rolling downhill, momentum gathers and soon it becomes impossible to push the vision away. It *must* be painted. Mystery unfolds: there are reasons for the way a graceful tree bends into the wind, or away; why fog hangs out longer in some places; why glassy reflections break apart on the surface of a pond when the breezes blow; and why sunflowers appear brighter when the sun is low. Nature yields countless secrets to those who genuinely pursue their visions.

As with most subjects, the deeper the commitment, the more we see. John Carlson (1875–1945) told us in his *Guide to Landscape Painting* that the unteachable part of art is "seeing." Frequently, what we look at can be understood at different levels. Many times we think we see, but only after discovering the obvious do the subtleties reveal themselves, and we never quite reach our goal because even that changes as we evolve. The important thing is to stay the course.

Innovative ideas about theme painting are more likely to surface when the mind is uncluttered. Meditation as

CALIFORNIA
DUSK
Pastel on
pastel card,
10" × 18", 2004

well as creative probing are stifled by the pressure of expectations, time limitations, or distracting urgencies. Each separate variation on a theme requires an adequate space of time for the artist to thoughtfully execute the work inspired by the idea. Sometimes wisdom appears to grow best in quietude.

First we paint the important compositional elements of the subject much as they appear. Next we explore the most obvious variations of the same motif. At this subtle departure, rather than just painting the subject, we begin to paint our *idea* of the subject. Soon the process proclaims its own order. It is much like establishing the height and width of an idea before beginning to explore its depth. We know that a line following the height and width of a two-dimensional scene will always take us halfway around the subject to the height and width once again, but in reverse, back to where we started. It establishes parameters. Rather than repeating itself by going around and around, the inquisitive mind will gravitate actively toward the *depth* of the idea as it searches for other relationship challenges. Inside the mind's kaleidoscope of tossing fragments, collected ideas catch the light and are observed by the discerning eye before they topple into other arrangements. Through the process of objective and constructive critique, some of the first work in a series may eliminate itself as new insights begin to unravel the obvious and reveal the essential "core of place."

Focus is primary as the artist begins to explore a theme. This is a most intoxicating time. We tread almost fearfully at the edges of a blank surface, not knowing with certainty whether our vision will materialize, or to what degree. We must trust our choices, be flexible when the surprises occur, and be able to ascertain when to go with the flow of the unexpected and when to pull in the reins and parallel the original idea. We may look to our muse for encouragement, knowing full well that the choices lie within our own brushstrokes.

When so much of the artist's spirit is at stake with each new venturing into depth of subject, it becomes easier to understand the highs and lows of the human psyche as well as the many interesting characteristics and colorful personality traits of some of the greatest artists. When a painting goes well, the artist is elated. The moment that it is not working, despair takes hold. It requires strength to balance the private moments of magic and madness in the studio. These are areas of the passion-driven mind that the artist struggles to harness and make sense of after leaving behind the initial height and width dimensions of ideas to pursue the unmapped depth. Artists who follow their muse, though bonded to a powerful idea, are still alone. Investigation of a single landscape subject through many expressions can take one to precarious places in the mind that are difficult to discuss and that no one else may care about or understand. But the joy for an artist on such an adventure that is successful is unparalleled.

Seriously exploring a landscape theme is one of those enigmatic pursuits that turns our thinking inside out and back again, taking us beyond our own brushstrokes to spaces where we may have anticipated mystery but find only simplicity.

During the course of brushing landscape meditations on our painting surfaces we will find them bewildering as well as simple, or simultaneously obscure and obvious, and, most of the time, joyfully profound. I wish you that joy in painting . . . and in life.

Historical Precedents in Theme Painting
A Brief Look at Favorite Paintings from the Past

MESMERIZED by the 24,600-year-old painted ponies on the damp walls of the prehistoric caves at Pech-Merle, France, one begins to realize that from the beginning of time artists were fascinated with the meaning of their chosen subjects beyond the mere application of line and color to a paintable surface. If indeed art is deeply connected to what the artist personally experiences, wouldn't it have made sense even then, and even with limited resources—namely black charcoal made from manganese oxide and red charcoal from iron oxide, both applied with bone fragments and twigs—to paint expressions of a subject often as a way of understanding the world in which one lives and the things that are in it? It seems reasonable to expect that it would also represent a method of realizing the intricacies of light and color and the changes that occur throughout the day, the year, or within any space of time. Series painting may be one of the earliest artistic responses to the beauty of nature as well as an attempt to unravel some of the mysterious wonders that it provides.

The paintings of Claude Monet (1840–1926) are largely responsible for renewing recent public attention to theme painting. His deeply personal series paintings go beyond their apparent subjects. They are highly informed explorations with clear, confident, and specific intentions. Monet was passionately dedicated to the tasks he set before himself in each group of canvases he worked on. He was the first to restrict an exhibition of his work to one series of fifteen works,

the *Poplars*. No modern landscape painter had ever done this. Monet's serialized imagery has clearly contributed to his reputation as one of the finest landscape artists of the century. Among the most famous series paintings by Monet are the *Grainstacks*, thirty luminous canvases of the Rouen Cathedral, the cliff paintings of Normandy, the hay and oat fields near Giverny, twenty-one meditative morning paintings of the Seine, and eighteen water lily paintings featuring his beloved Japanese bridge. Ninety of the series paintings created by Monet in the 1890s were collected and exhibited at the Museum of Fine Arts, Boston, The Art Institute of Chicago, and the Royal Academy of Arts in London in 1990—one hundred years later.

Today as always, series painting as well as theme painting powerfully calls attention to a given subject. While curators can address the dimension of depth within each controlled variation, they also assess the works' collective impact. Exhibitions consisting of series paintings enjoy a high level of public interest over long periods of time, and in their own way they help sustain awareness of the land that they are about.

While there are incredible examples of series painting in our museums and art libraries throughout the world, those pictured here are a few that I hope you will find inspiring. Some are exquisitely quiet; others are dynamically powerful. All are masterful expressions.

Jean-Baptist Camille Corot (1796–1875)

ALTHOUGH CATEGORIZING Corot's paintings still eludes art historians and critics, they all agree that his art was fueled by a profound love of the natural world, and that the vision he pursued was his own.

Corot traveled all over France and Italy looking for areas that inspired him. When he found such sites, he painted them often, almost obsessively. Corot painted so many views of Ville d'Avray—the home of his parents, where he lived for much of his life—that some critics called them "monotonous." Yet it was Ville d'Avray that played such an important role in developing Corot's intimate relationship with nature, and it was where as a young artist he sketched and painted the outdoors from a third-floor window in a tiny makeshift studio. Corot was fond of using architectural openings such as arches of an aqueduct, arcades of a basilica or villa, and ruins, which provided solid structural frames for luminous, fluid landscapes beyond. Corot painted numerous views of Rome, Fontainebleau, and the seaport at Honfleur.

Younger artists esteemed and dearly loved *le père* Corot while he lived, and in his later years, Corot came to be regarded by his contemporaries as a revered master and a painter of deep emotion. Today he is called "the very poet of landscape."

Corot peopled his landscapes with figures of his own imagination, which evolved into a distinctive poetic style. Pictured here are some examples of paintings that pay homage to the beauty of nature and yet acknowledge the presence of humankind. Notice the studied gracefulness of all of the trees in Corot's landscapes, the silvery tonality, and the use and careful placement of the tiny figures.

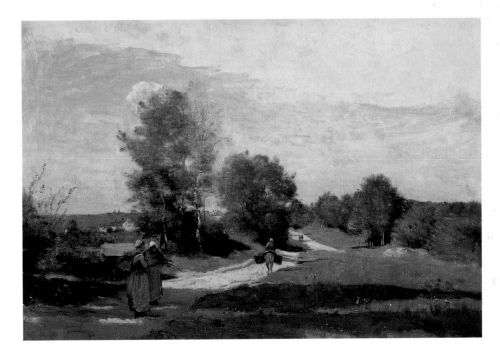

Jean-Baptist Camille Corot
A ROAD BY THE WATER
Oil on canvas, 15 3/4" × 23.82" (40 × 60.5 cm),
1865–70, Sterling and Francine Clark Art Institute,
Williamstown, Massachusetts

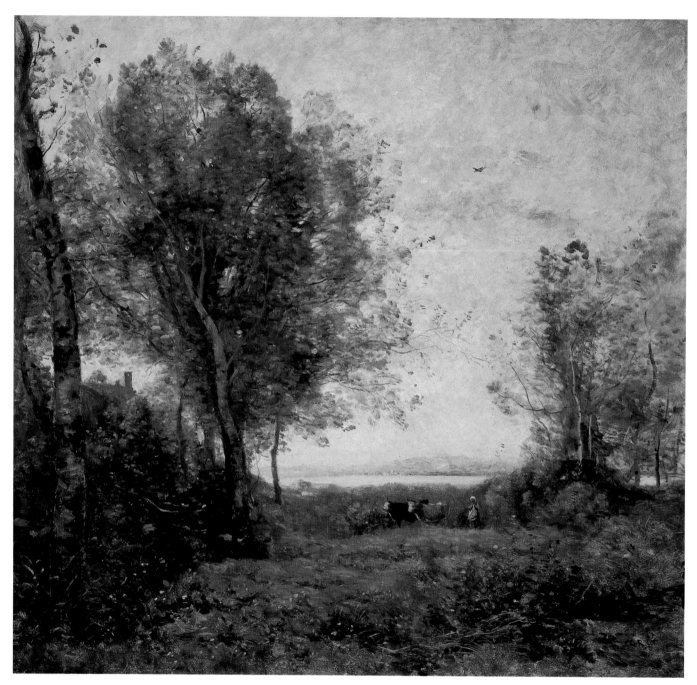

Jean-Baptist Camille Corot
MORNING—THE COW HERDER
Oil on canvas, 42 1/2" × 45.2" (109 × 116 cm), c. 1865–70, Musée d'Orsay, Paris

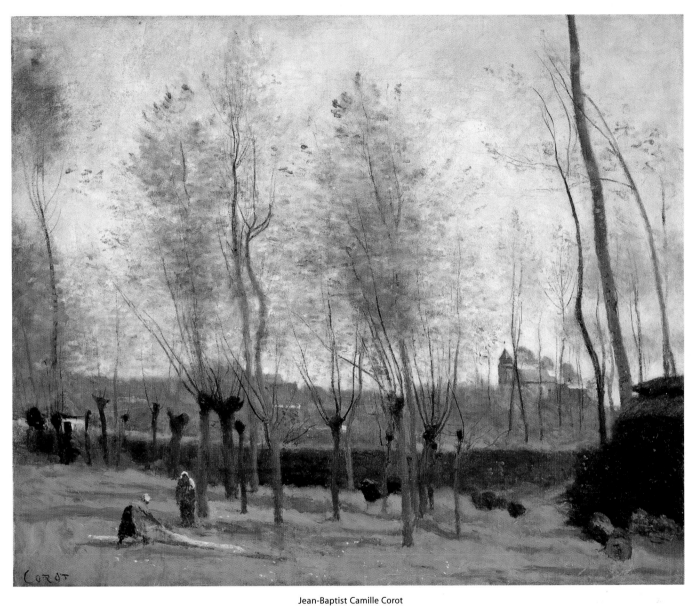

Jean-Baptist Camille Corot
WASHERWOMEN IN A WILLOW GROVE
Oil on canvas, 15" × 18.15" (38.1 × 46.1 cm), 1871,
Sterling and Francine Clark Art Institute, Williamstown, Massachusetts

Martin Johnson Heade (1819–1904)

MARTIN JOHNSON HEADE produced the most varied body of work of any American painter of the 19th century. According to his biographers, he was highly unconventional in his life and in his approach to painting. Heade is best known for his highly detailed and accurate Central and South American paintings of hummingbirds with orchids and passionflowers. He also painted numerous series of seascapes and still life featuring magnolias. Some of these themes lasted a short period of time while others continued for over a decade or more.

In the 1850s he became interested in landscape painting and wrote to a friend, "I find landscape painting not quite so easy as I supposed." Heade, however, quickly gained mastery of everything he tried, and after painting with the leading Hudson River School painters for a while, he adapted what he learned to his own vision and, with incredible energy, painted landscapes of astonishing originality.

Martin Johnson Heade was "a romantic masquerading as a realist." He insisted that painting had more to do with memory than fact, and less to do with keen observation than the artist's imagination.

Heade did over a hundred paintings of the northeastern salt marsh. He painted his subject at dawn and at sunset, and under every kind of atmospheric condition. "Heade painted the marsh in the way that Thoreau wrote of Walden Pond, describing every detail, every nuance of an area that to most seemed mundane and forgettable."

The three salt marsh paintings pictured here are poignant examples of an artist's inspiring love of place.

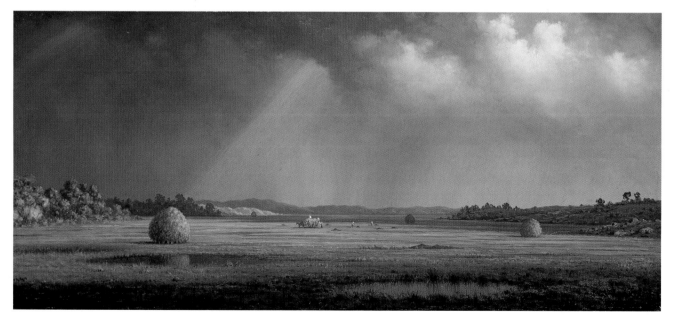

Martin Johnson Heade
NEWBURYPORT MEADOWS
Oil on canvas, 10 1/2" × 22" (26.7 × 55.9 cm), ca. 1876–1881, The Metropolitan Museum of Art, New York

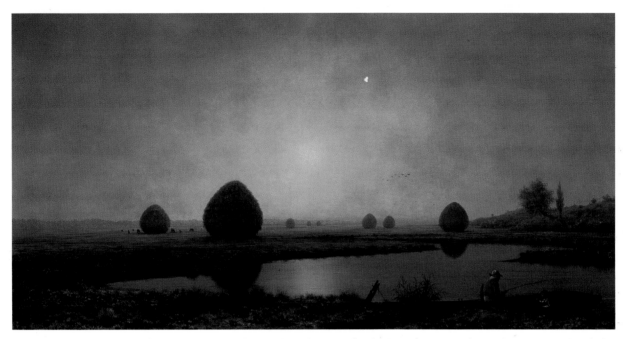

Martin Johnson Heade
SUNRISE ON THE MARSHES
Oil on canvas, 26" × 50¼" (66 × 127.6 cm), 1863, Flint Institute of Arts, Michigan

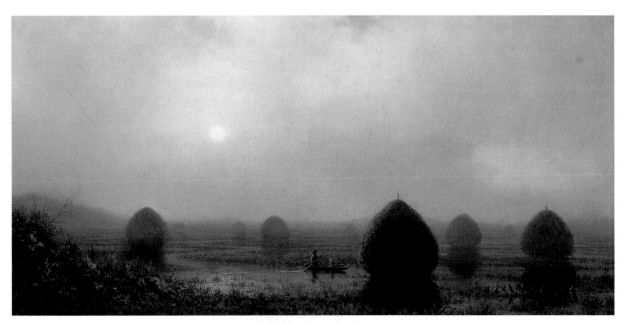

Martin Johnson Heade
THE GREAT SWAMP
Oil on canvas, 14⅞" × 30⅛" (37.8 × 76.5 cm), 1868, Fine Art Museums of San Francisco, California

George Inness (1825–1894)

GEORGE INNESS is now considered the "father of American landscape." During his lifetime, he moved from literal, precisely detailed representations of nature to deep meditative, moody, and magical impressions. The majority of his landscapes are of favorite recurring themes often inspired by memory and imagination. There are more than twenty paintings based on Étratet, and over a dozen of Montclair, New Jersey. Inness used the idea of low light in many of his later poetic landscape paintings, and at the same time he was able to keep his palette rich and sensuous. He became the master both of eliminating the extraneous and of portraying the powerful *idea* of place. He is quoted as exclaiming with passion, "The subject is nothing."

In the final decade of his life, Inness created a filmy, dreamlike quality in his paintings with the use of ethereal color, superbly delicate brushwork, and significant omission of detail. At that time, while biographers described Inness as a frail, sensitive man, his son described his elderly father as a "madman in his studio," filled with the dynamic energy of inspiration as he created compositions from his own brain but based on a thorough knowledge of nature. Today, George Inness' paintings are significantly poignant contributions to the development of art in this country.

These inspiring examples of Inness' work show how the idea of painting a favorite place at dawn or the end of the day, when light is just beginning or ending, can be used by the artist as an ongoing theme. This particular theme of early or late light has appealed to landscape artists throughout history and is still one of the most popular today.

George Inness
SUNSET GLOW
Oil on canvas, 14³/₄" × 24" (37.5 × 61 cm), 1883,
Montclair Art Museum, New Jersey

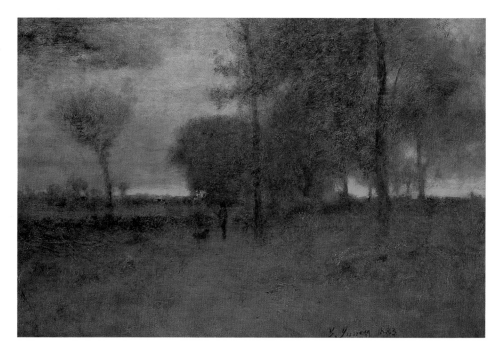

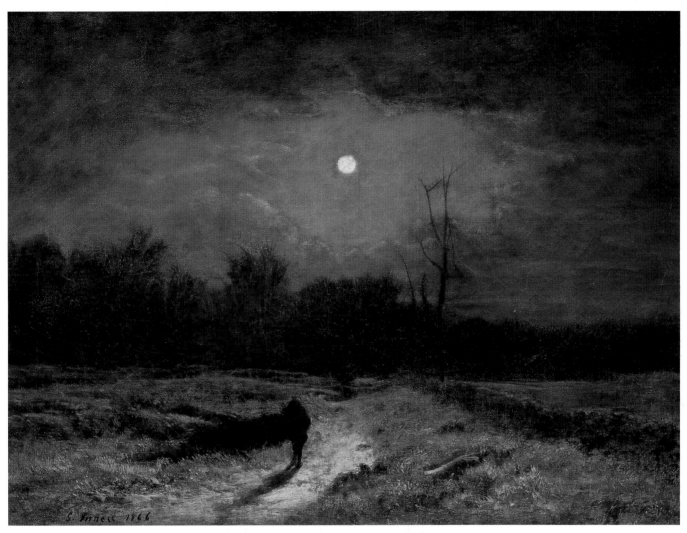

George Inness
WINTER MOONLIGHT (CHRISTMAS EVE)
Oil on canvas, 22" × 30" (55.9 × 76.2 cm), 1866,
Montclair Art Museum, New Jersey

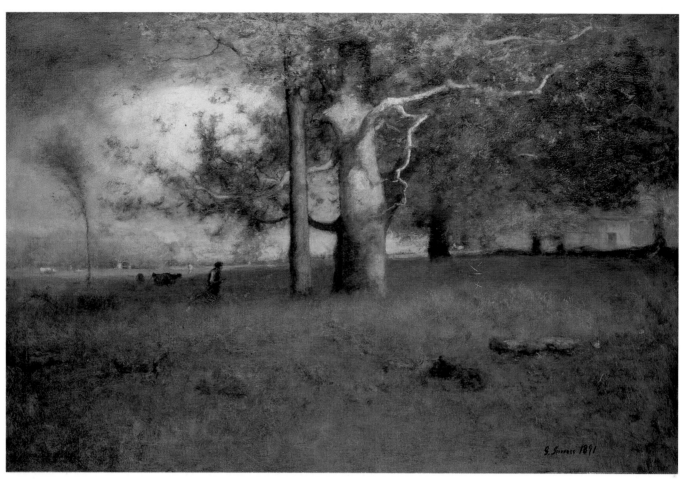

George Inness
EARLY AUTUMN, MONTCLAIR
Oil on canvas, 1891, Delaware Art Museum, Wilmington, Delaware

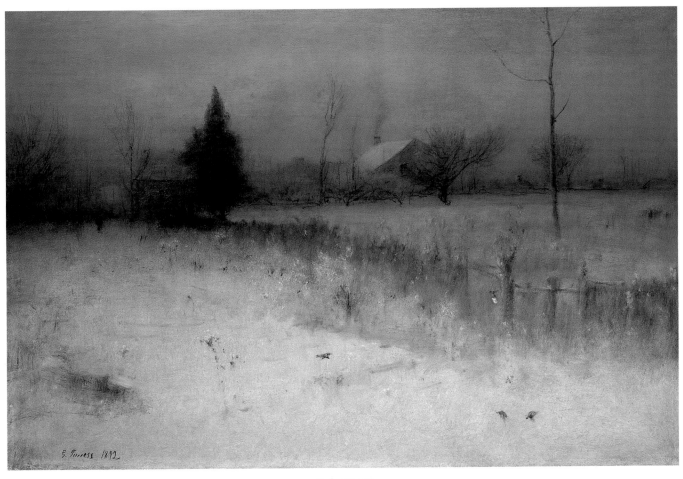

George Inness
HOME AT MONTCLAIR
Oil on canvas, 30⅛" × 45" (76.5 × 114.3 cm), 1892,
Sterling and Francine Clark Art Institute, Williamstown, Massachusetts

Marius Breuil (1850–1932)

THE TREE STUDIES and groups of trees painted by French landscape artist Marius Breuil demonstrate this artist's sustained interest in what may have been his favorite subject. Breuil's charcoal and crayon drawings, pastels, watercolors, and oil paintings of the landscape in southern France are examples of his immense skill with many different mediums. More than that, they are evidence of a thorough knowledge of subject. In Breuil's own words, "If I had to make a distinction between genres with regard to their tendencies and the skill they require, I would rank the landscape painter first among our artists." Breuil also stated, "However, verve by itself cannot create great works and the artist who knows how to awaken our feeling for nature, its rusticity, its naïvety, its poetry, and its light in a different way is equally worthy of our admiration."

Breuil's paintings are richly beautiful in their simplicity. For example, a painting of an olive grove is just that and nothing more. It does not need to be more. A single idea is paramount in all of Breuil's work.

The three modest examples shown here clearly depict the difference between painting the idea of a subject as opposed to its reality, and how similarity of a simple, singular landscape component can be examined as a suitable and exciting motif. Always a characteristic essence of the tree's beauty is carved out and away from any complication that may have existed in the background. "A painting will never be a study of details; the general impression is paramount," according to Breuil.

Nearly 400 paintings and drawings, recently discovered by Gérard Ferrua, can now be seen on the Internet at http://www.marius-breuil.com.

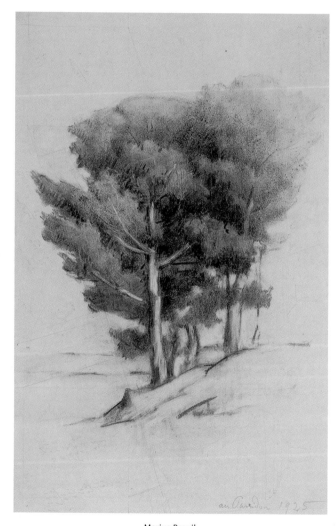

Marius Breuil
BOUQUET D'ARBRES
Charcoal, 19.5" × 12.9" (50 × 33 cm), 1925, collection of Gérard and Paule Ferrua

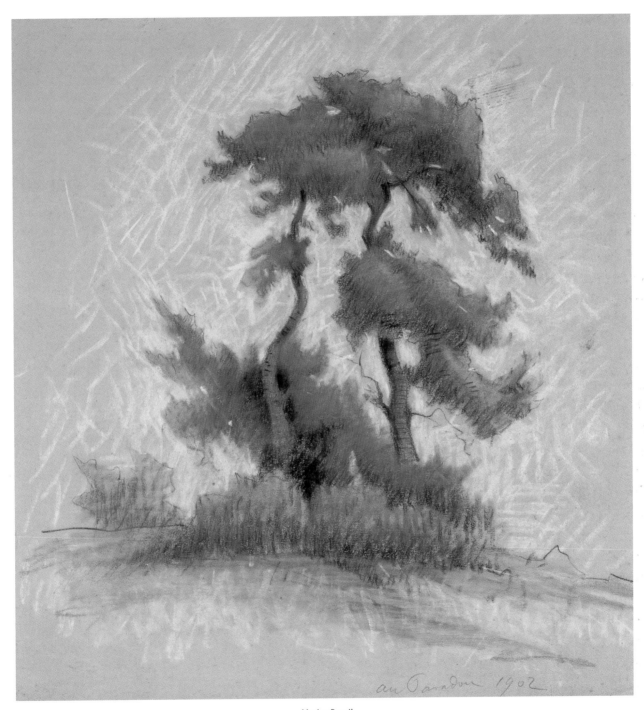

Marius Breuil
LES DEUX ARBRES
Charcoal, sanguine, and chalk, 12.9" × 11.3" (33 × 29 cm), 1902, collection of Gérard and Paule Ferrua

historical precedents in theme painting

Marius Breuil
DANS LA PLAINE DES ANGLES
Oil on board, 9.8" × 13.3" (25 × 34 cm), 1885, collection of Gérard and Paule Ferrua

William R. Leigh (1869–1955)

WILLIAM ROBINSON LEIGH was an American painter of the Southwestern landscape and of the African landscape. He was a painter who believed that an artist can never know his subject too well.

In 1926 the American Museum of Natural History was in the process of constructing the African Hall, which was to set a standard of excellence in museum exhibitions. Leigh was hired as the professional painter to paint backgrounds for new exhibits. Besides being accurate, they were to convey an overall sense of "the essence of Africa." Leigh was struck by the unexpected beauty of the African landscape, and during the expeditions to Africa, he did many studies of his own.

The works by William R. Leigh included here are excellent examples of same-subject exploration and the surprisingly powerful subtlety that can be achieved within a theme that is not compromised by the unnecessary. His paintings of cloud formations over the African plains are worthy of study by every landscape artist. They give appropriate space to what the artist has deemed most important—the drama in the sky. The subject of clouds remains a favorite of many landscape painters today.

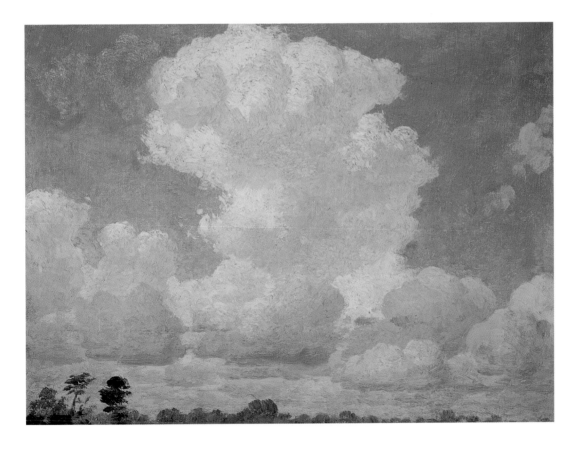

William R. Leigh
CLOUD FORMATIONS
Oil on board,
12" × 16" (30.5 × 40.6 cm),
Gerald Peters Gallery,
New York, New York

William R. Leigh
STUDY FOR WILD DOG GROUP I
Oil on board, 12" × 16" (30.5 × 40.6 cm), Gerald Peters Gallery, New York, New York

William R. Leigh
STUDY FOR WILD DOG GROUP II
Oil on board, 12" × 16" (30.5 × 40.6 cm), Gerald Peters Gallery, New York, New York

William R. Leigh
FULL MOON AT LATE TWILIGHT ON THE PLAINS OF TANGANYIKA
Oil on board, 12" × 16" (30.5 × 40.6 cm), Gerald Peters Gallery, New York, New York

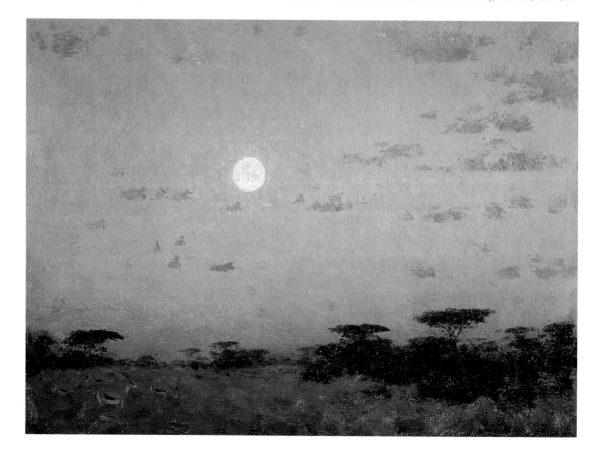

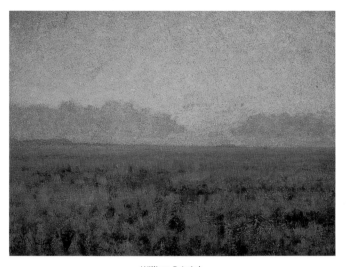

William R. Leigh
STUDY FOR WILD DOG GROUP III
Oil on board, 12" × 16" (30.5 × 40.6 cm), Gerald Peters Gallery, New York, New York

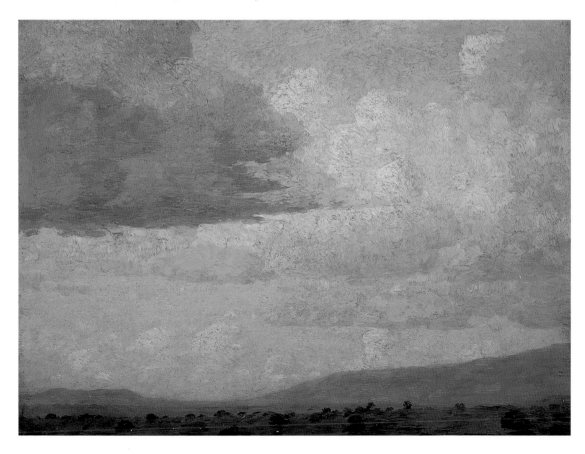

William R. Leigh
SUNSET SKY ON THE ATHI PLAINS
Oil on board,
12" × 16" (30.5 × 40.6 cm),
Gerald Peters Gallery,
New York, New York

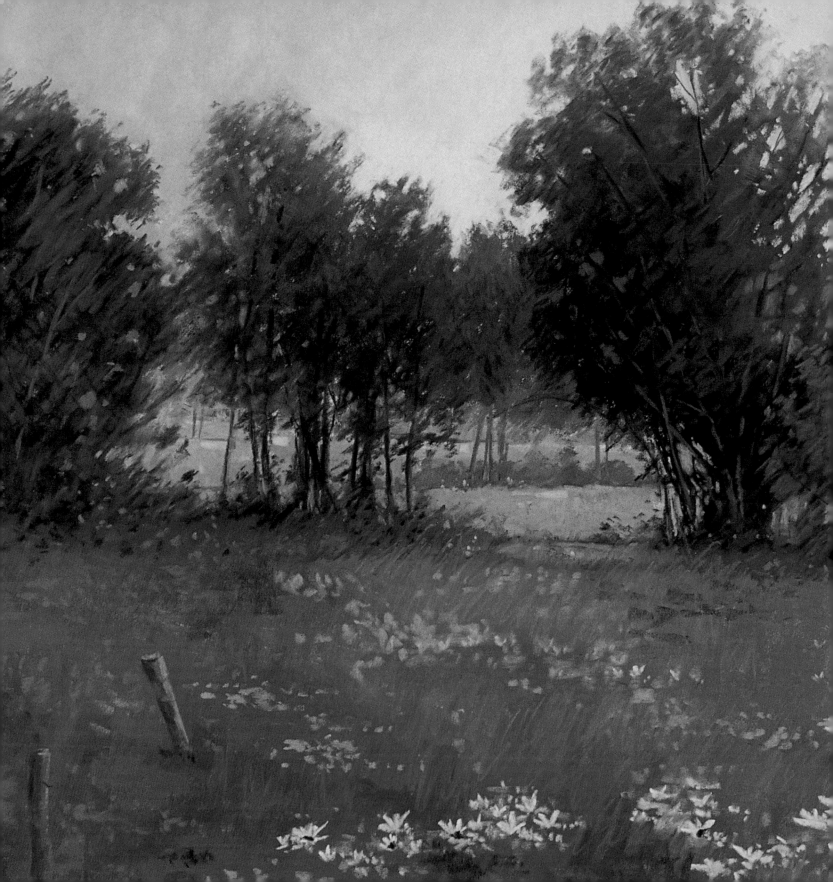

CHAPTER 1

General and Specific Topics

Wildflowers in the Landscape

THE APPEAL OF FLOWERS in a natural setting is universal. They are gentle evidence of renewal and continuance. Wildflowers offer the artist an extremely general theme—and a very common one. Most landscape artists paint wildflowers at one time or another; many paint them consistently.

If you have not painted within a theme in the past, selecting a general topic may be an effortless way to begin. In fact, if you think of some favorite subjects, you will realize that you already have paintings that fit into any number of categories you may wish to stay with, work around, or expand upon. In this instance, you may purposely keep the theme open and general and paint wildflowers wherever they can be found. As an example of this approach, the paintings in this chapter show wildflowers in their environment. Some are commonly found near my home and others were encountered in my travels. Like many artists, when I see a field or grove of flowers, I frequently stop to take a photograph and make some color notes whenever possible.

One of the most important considerations of the artist painting wildflowers has to be placement. Nature tosses color onto fields and hillsides in seemingly erratic patterns. Actually, natural arrangement is determined by quality of the soil, degree of moisture, and how the seeds were distributed, whether by birds or other animals, wind, or dried seed falling from older plants already there. Although wildflower distribution in a painting can be manipulated to enhance the composition, the artist needs to pay careful attention to variation in the size and arrangement of the groupings. Where flowers do not appear is as important as where they do. Also keep in mind that when flowers appear in a shaded area, they too will be in shadow. Detail in just a few is usually enough, leaving most of the others simply suggested by the shape of the stroke.

My own experience in painting landscapes that include wildflowers is that my paintings are more successful if I limit the color and the number of flower varieties to one or two, three at the most. As the number of colors increases beyond that, the overall impact of the painting lessens. And of course you will remember that the sizes of the flowers must diminish proportionately from foreground to background with consistency. A one-inch upright stroke representing a flower stem at the horizon has the potential to read as being eight feet tall depending upon the foreground treatment. Exuberance that is distributed with discretion rather than carelessness is more effective.

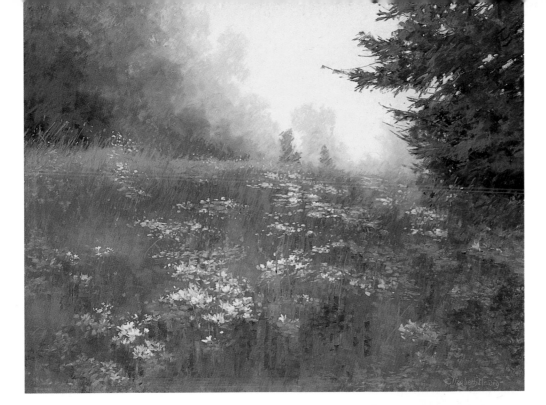

I frequently walk past this view near my home. One overcast morning when it looked like this, I decided to paint it. The placement pattern of the tiny purple and white wild asters leads the eye uphill through the drying grasses to where barely visible tree shapes meet the sky. Note the diminishing size of even a tiny variety of flowers from foreground to middle ground.

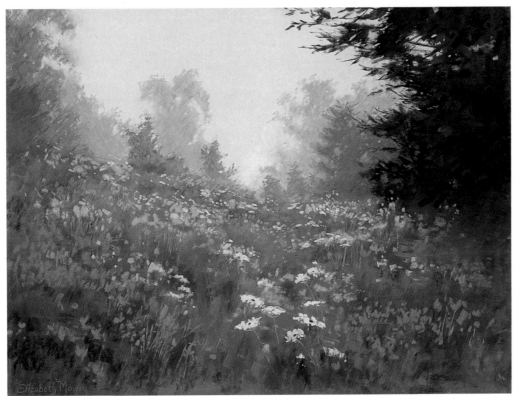

After painting September's Wild Asters, *I began to pay more attention to this field as seasons passed. The following summer, on another foggy morning, a different combination of seasonal wildflowers graced the sloping hill. I find that it is easier to set a quiet mood on hazy days when strong sunlight and shadow contrasts do not dominate my composition.*

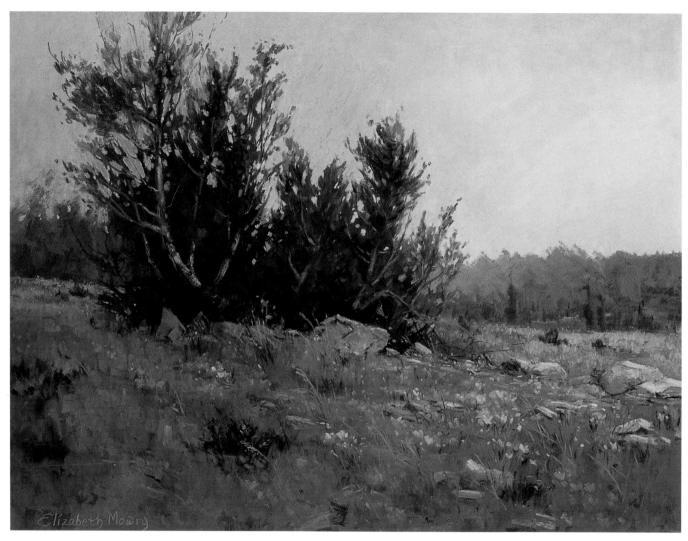

NEW ZEALAND POPPIES
Pastel on mounted sanded paper, 18" × 24", 2003, collection of Ginger and Les Tronzo

Most often I find the New Zealand landscape too overwhelmingly beautiful to paint: the water is aqua blue; poppies, lupine, and calla lilies are wild and profuse; the shorelines are dramatic; and wildlife is incredibly abundant. I have not yet learned to handle this sensual overload successfully on the painted surface. The foreground of this scene in reality was so thickly covered with pink and purple lupine in addition to the orange poppies that hardly any grass was visible, and there was a clear aqua lake just to the right of the trees. I had to edit seriously before I could get the painting to work.

*A warm, transparent
light in the sky gently
blesses some of the
flowers in this field,
giving color move-
ment to a still subject.*

HIGH MEADOW
Pastel on sanded paper, 12" × 12", 2000, collection of Robert Mc Nutt

SUMMER BREEZE
Oil on canvas, 5" × 8", 200

*These daisies and poppies were in France, but are common in
many places. Because the painting is about the flowers, the horizon
is high so that the primary idea is given the most space. Movement
within the square format is evident in the clouds, the trees, and
the bending grasses.*

*The purpose of studies such as this is to capture the movement,
and the moment. For me, this one worked better tha ause of
the diagonal clouds in concert with the reverse diagona eside
hill. Wild poppies in the foreground provide a natural color t.*

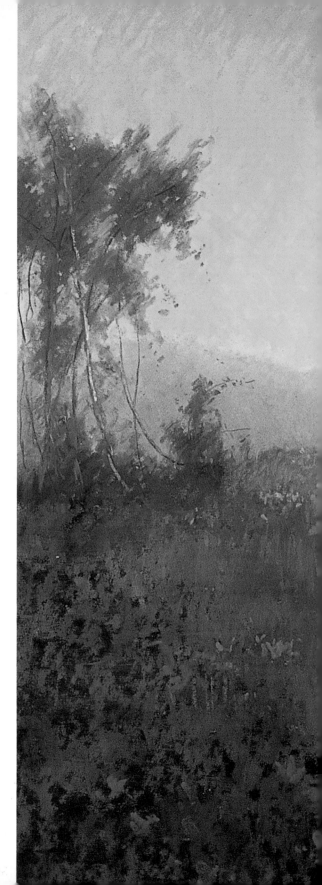

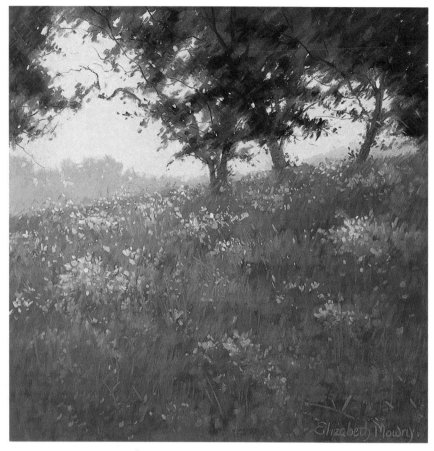

NAPA VALLEY HILL
Pastel on sanded paper, 12" × 12", 2002

A hillside of spring flowers dominates the space in this composition. Diffused light touches only the flowers near the crest of the hill, keeping the painting quiet. This becomes possible because the foreground grasses and flowers are painted with values that are near one another, making the foreground of the painting less important.

FROM DOSTOYEVSKY'S WINDOW
Pastel on mounted sanded paper, 26" × 32½", 2004

This is the fifth painting of a favorite scene. (Others, titled Beckoning I, II, III, *and* V, *can be seen in Chapter 7 and* Beckoning VI *appears in Chapter 3). Here we see how far the exploration of color temperature in a single place can progress. All of the separate hues in this painting would be considered warm; together they interact relative to one another in degree.*

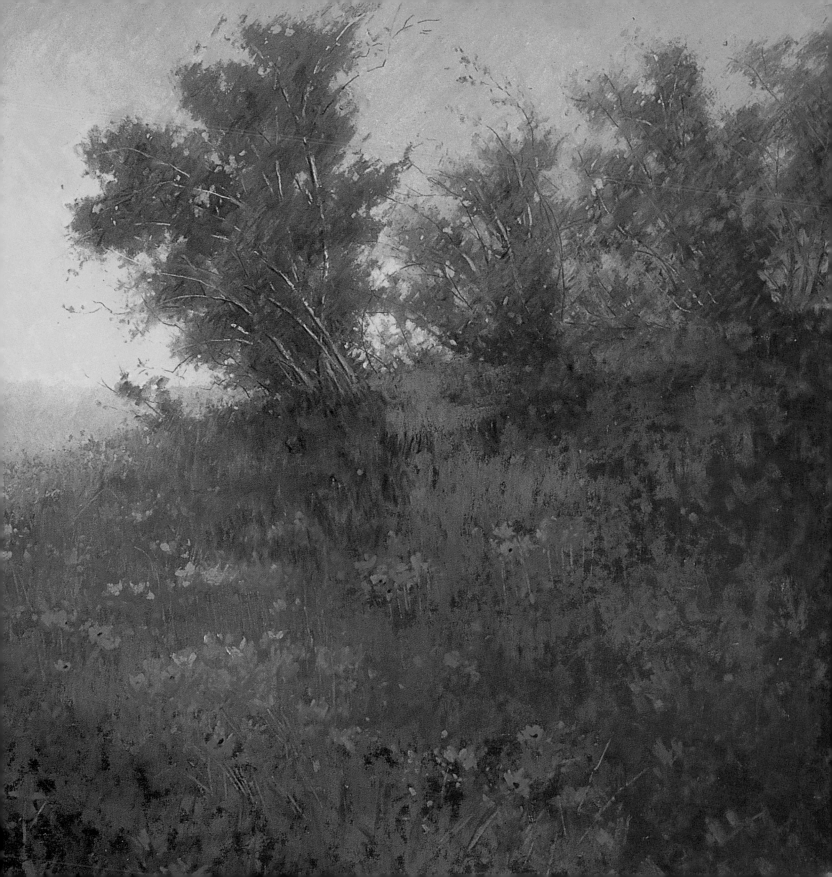

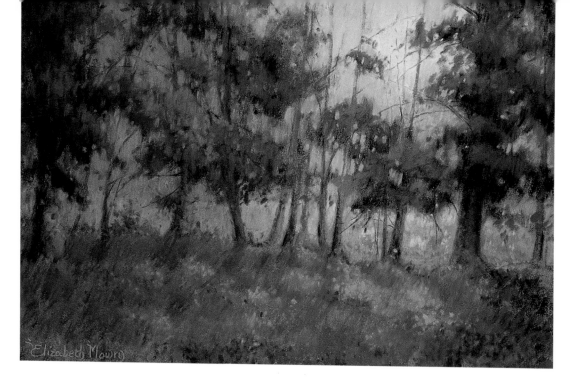

BLUEBELLS IN MAY
Pastel on pastel card,
11" × 16", 2003,
private collection

*Morning sun lights a
field that is barely visible
beyond a row of trees.
Spring flowers grow
profusely in their natural
environment. I refrained
from painting detail as
soon as I realized that
the color wanted to sing
its own song.*

right
WILLOWS II
Pastel on board, 12" × 10", 1998

*I have painted this scene several times in oil
as well as in pastel. I view it as an example
for myself of "less is more." It would have been
easy to fill the foreground with a profusion of
flowers, but in this case the painting is stronger
because I did not.*

opposite
WILLOWS III
Oil on canvas, 18" × 24", 2004

*Unity of color was obtained in this oil
painting of willows by glazing with Naples
yellow. Before glazing, there were a few spots
of color tension that diminished the overall
potential for harmony in the scene.*

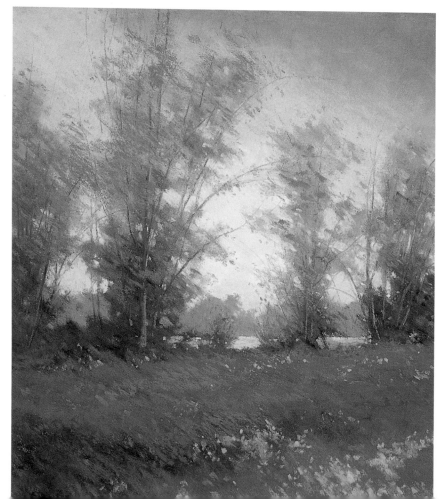

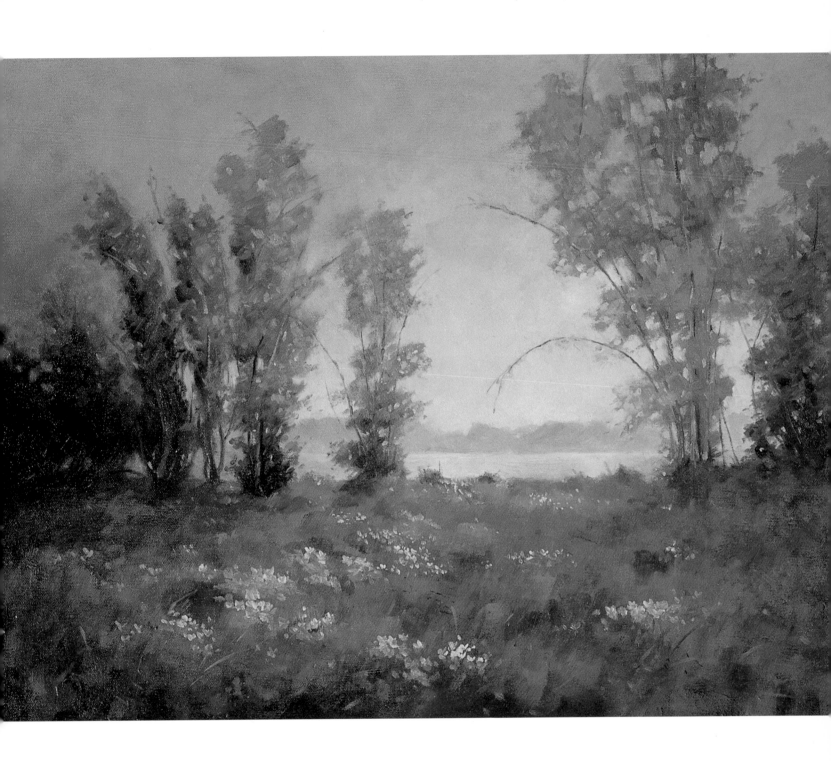

MAGNOLIA
6" × 8"

LETTUCE POPPIES
10" × 8"

CLEMATIS
7" × 9"

JACK-O'-LANTERNS
6" × 4"

IRIS
6" × 4"

Painting on-site small studies of flowers, such as these, requires us to look carefully at the color variations, shape, and distinctive characteristics of each variety. We can hone our skills this way, and perhaps even in our own garden, by painting both wild and cultivated varieties, as I did. Then simply suggesting flowers in a landscape painting where detail is secondary becomes easy to do.

CHICORY
5" × 7"

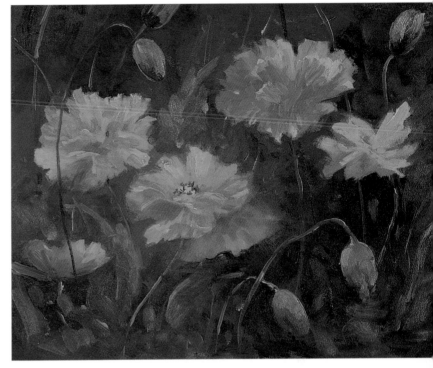

ORANGE DOUBLE POPPIES
8" × 10"

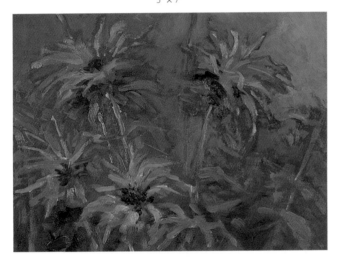

BEE BALM
6" × 8"

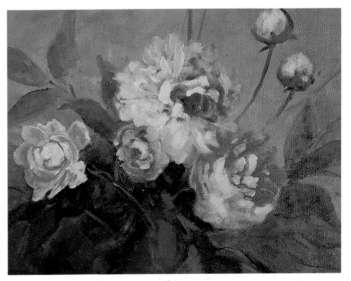

PEONIES
9" × 11"

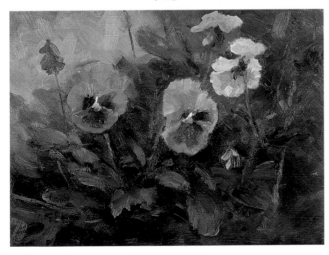

MAGENTA PANSIES
6" × 8"

Thoughts: Artist to Artist

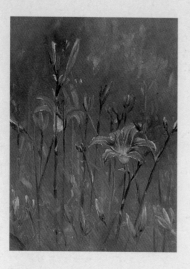

KNOWING one's subject is always important, especially when it has to do with nature. We can change and rearrange trees, clouds, flowers, and the edges of a mountain stream, but it helps to have observed these things carefully beforehand.

My mother was a woman who loved flowers, and an abundance of the common varieties graced her garden. I was allowed to pick bouquets freely for our modest home, which was in a small, friendly, ethnic community. I learned the names of all the flowers in our garden even when they were taller than I was. For some time we did not have an automobile, so taking walks through nearby fields and woods with my parents was a weekend event. There, too, I picked flowers with my parents to take home.

Then I learned a very important lesson. Up until that time, flowers—to my knowledge—were to be picked, and brought rewards such as happy smiles and hugs from the people I loved. My young brain was very active but categories were still general and unrefined. One day all of that changed as I rang my own doorbell with my pinky because my arms were filled with forty-five peachy-pink tulips. My mother opened the door, gasped, and called to my father, who had been reading the Sunday paper. The color drained from his face, and my mother began to cry at the same time the phone began to ring.

That was the day my education took a huge leap forward. I learned the difference between "wild" flowers and cultivated ones, and that friendly old neighbor ladies can act real mean and say bad words, too. (And I had been so proud to keep a secret and hold back my four-year-old enthusiasm all week just waiting for every one of those tulips to open up and look so beautiful before I snapped them all off!)

Later on after everybody calmed down a bit, I announced that I didn't want any *damn* supper anyway! and I immediately learned another lesson about the new word I had heard earlier. What a day! When I was sent to bed, I was just glad it was over. But now I do know the difference between wildflowers and cultivated garden flowers, and over the years I have developed an inordinate respect for private property.

Lavender Fields

WITHIN ANY GENERAL THEME, many specific possibilities exist. Sometimes we become enamored by a persistent idea, but we feel insecure about whether we have the level of skill needed to execute it at the same level as our vision. Or perhaps the amount of time that elapses while we are engaged in completing other projects forces us to realize that the idea has become stale or overdone. At other times, we become so thoroughly captivated by a motif that it simply will not let go.

This small group of paintings is the direct result of a lifelong fascination with the scent of lavender beginning when as a child I would sleep with a bar of lavender soap near my pillow. Still a favorite fragrance, and in its own quiet way, it has begun to integrate my life. I now grow lavender in my garden; I use it in a growing number of eyebrow-raising but well-received recipes; I have raffia-tied bundles of it throughout my home (and the moths have moved out); my library collection of books about lavender is spreading over more and more shelves; and I am beginning to explore the possibility of growing a field of it so that little children can come to pick a bouquet and learn a few French words or perhaps a little song. A few years ago, a dear friend and I researched the flowering time and location of wild and cultivated lavender fields in France. Then, despite all advice not to visit the country during the heat of July, we did just that. (Impassioned artists are free to disregard any well-meaning advice that stifles connection to subject.) Upon arriving in France, we visited the Lavender Museum to broaden our understanding of our subject. The next three weeks allowed us to visit most of the major lavender-growing areas of southeastern France. I cannot possibly find words for how overwhelmed I was day after day after day by the mosaic of purple fields that extended in every direction as far as the eye could see, and by the intoxicating scent that permeated the hot summer air. I was grateful and ecstatic. I intend to return to these lavender fields so that I can learn more and then paint them again. In the meantime, some of the first obvious expressions shown here represent an example of a specific theme, *Lavender Fields*, within the general subject of flowers in the landscape.

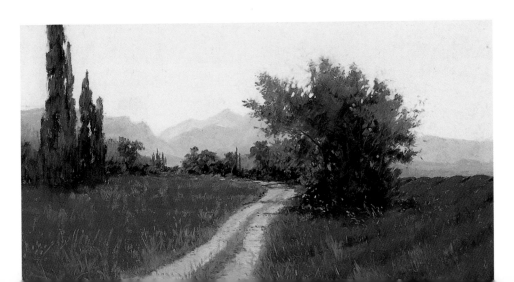

LAVENDER #3
Pastel on sanded paper, 10" × 17", 2003, collection of Lauren and Kevin Erkenbrecher

When the lavender is not growing in rows, it is cut by hand with a sickle and placed by workers into large white canvas sacks that dot the fields at harvest time. This field was on a plateau. In the background are the mountains loved and painted by Cézanne.

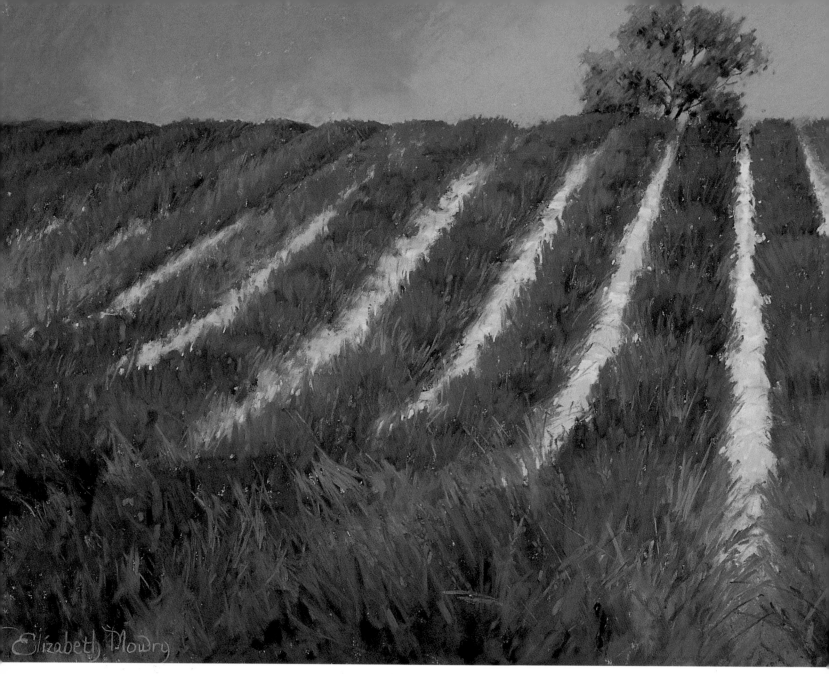

LAVENDER #1
Pastel on sanded paper, 12" × 16", 2003

The essence of a cultivated field is the subject of this painting. I think I would need a 100-inch-wide painting surface to more accurately convey the impact that I felt. The entire region was covered by field upon field of purple.

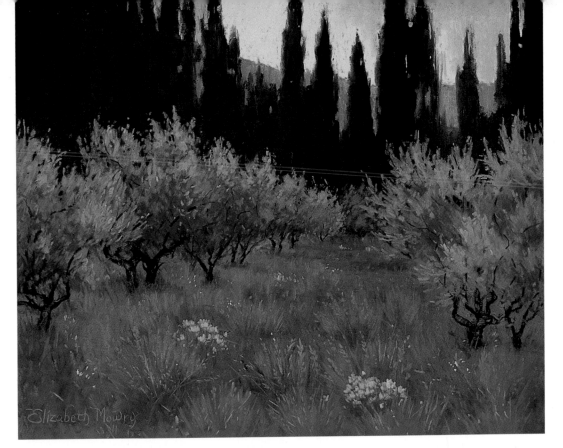

LAVENDER #2
Pastel on sanded paper,
14" × 17", 2003,
private collection

Subject matter runs "over the top" as I find three favorites together: the dark distinctive shapes of cypress, the elusive blue-gray color of the olive trees, and, of course, the lavender. Even the long summer days were not long enough!

LAVENDER #7
Pastel on mounted sanded
paper, 8" × 13", 2003

The scene is the same as in Lavender #2, *but now in the day's first hazy light. In both paintings the lavender grows without the formality of rows. Nevertheless, it is an integral part of the landscape of Provence.*

LAVENDER #4
Pastel on sanded paper, 10" × 10", 2003, private collection

This is a common scene: a ruin in the midst of the patchwork of lavender and cereal fields where scattered farms appear in the hills of southeastern France.

LAVENDER #5
Pastel on sanded paper, 10" × 10", 2003, collection of Nancy and Scott Sherr

After the subject becomes familiar, we can begin to experiment with different formats, subtraction of some elements, introduction of an eye-catching color note, and other ideas that surface.

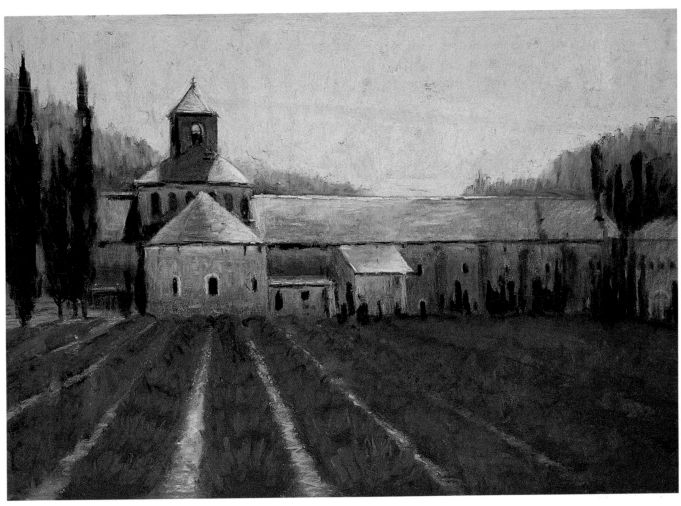

LAVENDER #6
Pastel on sanded paper, 7½" × 10½", 2003

The structure of this beautiful monastery, Abbaye de Sénanques, adds a strong "human presence in reserve" to this scene. Monks harvest the flowers for essential oil and honey. Learning can be an important element of any painting exploration of theme, but flexibility is nearly always a prerequisite.

LAVENDER #8
Pastel on sanded paper,
7" × 10", 2003

The soil and the climate have much to do with growing lavender successfully. Here the sky, a lone tree, and the fields provided an exquisite palette. No adjustments by me could have improved upon it.

LAVENDER #10
Pastel on sanded paper, 5" × 13", 2004

The greater artistic license, cropped composition, and warmer color temperature in this painting may have been influenced by the almost deafening, heated, incessant song of nearby cicadas as I painted at the site. This grove of oaks in the Lot Valley provided a pleasing shape contrast to the scene. Look for composition possibilities and assess whether some rearrangement might strengthen your painting.

Thoughts: Artist to Artist

SOMETIMES an idea will not be ignored or even overlooked. I wasn't ready for this one even after much of a lifetime, because fields of lavender are not common where I live, and although I presently have about fifty-five plants in my garden, I had never seen a field of lavender, much less one that stretched to the horizon line. I believe that mere coincidences are more than what they seem to be, and when an opportunity to explore an idea presents itself, and it is 100% what we really want to do, we have to see it as a green light, and act. In the big picture, the worst that can happen is that it doesn't work or turns out not to be what we had hoped, and within the agony and ecstasy of the artist's lifetime, the experience will surely fit in somewhere. It is important to attach validity to falling in love with a place without having to list the practical reasons why.

The paintings here comprise an excellent example of an incomplete theme, not yet fully refined or resolved. When I decided to "harness my paint box" to the stars that were twinkling over lavender fields far away in another country, the learning had just begun, but it will continue because the passion was sustained by being in the place, and fired even more by the overwhelming beauty of what I found there. So far I have just barely touched the surface, and I am fully aware that the reality I have painted is only the obvious beginning, after and beyond which creativity unfolds. I look forward to future "purple" mysteries unfolding on my painting surface. Evocative, abstracted, ever questioning . . . who knows? I am elated. If I pursue and am blessed with success in the pursuit, my guess would be that these first images pictured here will become simply passages leading to an outpouring of bountiful visions yet to be painted. The ideas already flow freely, tapping dormant memories with dizzying speed so that the bigger concern will be whether my remaining years and my skill will equal my passion.

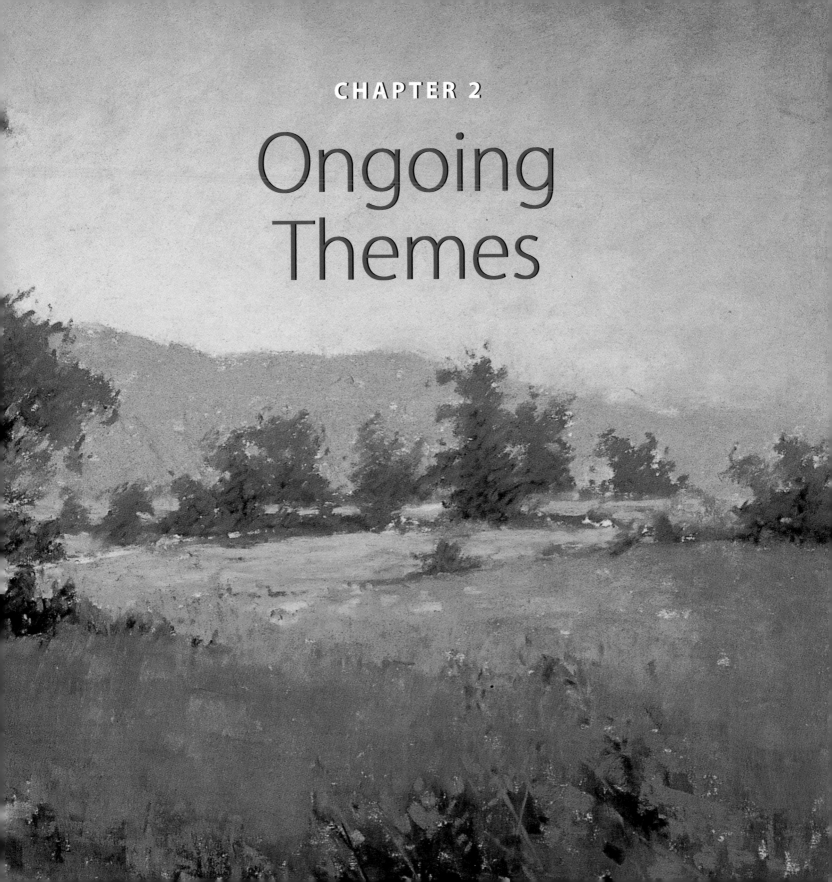

Ongoing Themes

A Metaphor for Life

SOME THEMES are so universally common that they become motifs for many landscape artists, and are painted at some time or other by most. Roads, paths, and waterways fall into this vastly comprehensive category. Not only are these, or views of them, generally accessible to most people, they are themselves a means of access. Everyone can relate to them and to paintings of them as well.

This inclusive type of theme does not have to be attached to a time line. Instead it can be ongoing, and even sporadic, but always unforced. The unconstrained approach in itself will result in higher quality, thoughtful compositions rather than simply a larger number of them.

Common painting themes may also reflect a lifelong interest of the artist. Roads, paths, and waterways pull at us with blatant tenacity, and even when we think we've painted our final versions of them, we may find that at the very next painting opportunity we are setting up our easel again in a place with a view of the same irresistible motif.

APPLE ORCHARD
Pastel on panel, 12" × 16", 2000, private collection

A truck road winds through this orchard near my home, where every season holds possibilities for more paintings.

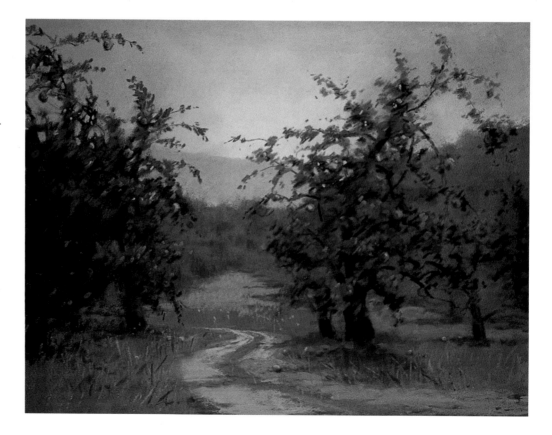

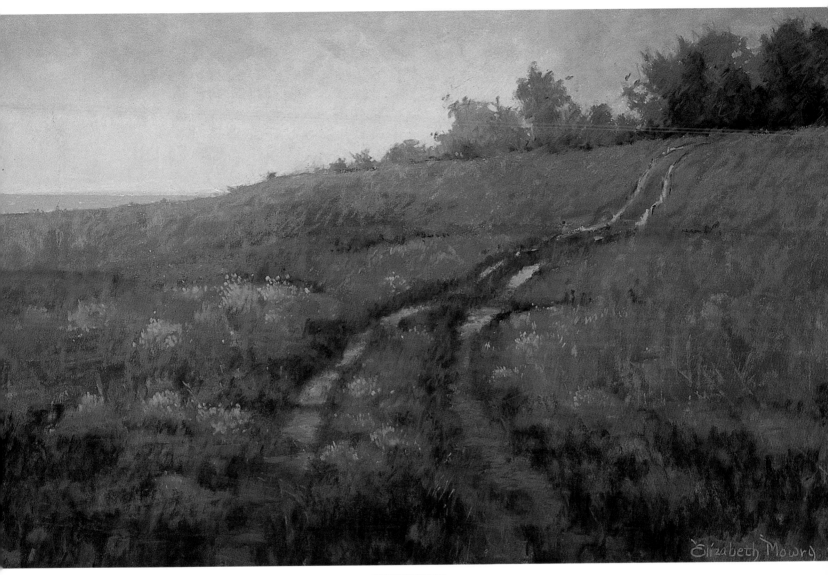

SOMEWHERE HILL
Pastel on pastel card, 16" × 25", 2003

Although I cannot remember where this scene was, I do recall stopping the car to take a photograph when I saw how gracefully this muddy truck path carved uphill through the emerging spring color. I keep a file of favorite theme photos in boxes and then enjoy looking through them and (most of the time) remembering when and why I was there. Paths are also made by animals tracking through the snow and airplanes crossing the sky. It is interesting to follow them and find the story or simply wonder what it might be.

Roads and Paths

BECAUSE OF the sweeping nature of many popular themes, ongoing expressions of them can be diversely exciting. The possibilities of expanding separated parts of the theme are practically endless. Think of it: roads approaching distant towns; roads through narrow, twisting streets; roads opening to views of the countryside but still framed by the last few structures at the village's edge; roads ushering us right up to colorful street markets; roads at intersections large or small, or at a fork where one decides which of two directions to follow; roads into dense forests; even roads switchbacking up a mountainside—or disappearing, straight as an arrow, into the mysterious haze of a desert.

Visualize yet more, much of which you can relate to as you travel about: access paths through sandy dunes to a beach; single-passage trails to breathtaking vistas, or even farther, to where only big sky hugs a barren terrain; slippery paths over mossy rocks where the crashing of waterfalls ahead drowns out all other sound; or simply paths to outbuildings behind rustic dwellings, or through moonlit snow in Russia, or along bicycle paths through the purple heather in Denmark.

(Sometimes a mind so oppressively overflowing with ideas is a blessed curse because coexisting with the proliferation of ideas is the realization that no human life is long enough to pursue them all.

ROAD, SOUTH CAROLINA
Pastel on pastel card,
5" × 8", 1997

Ultimate simplicity invites open-ended conclusions. The dirt road here catches more light than the vertical trees. It actually abandons the viewer, but at the same time invites personal associations with a nonspecific scene that most people can relate to.

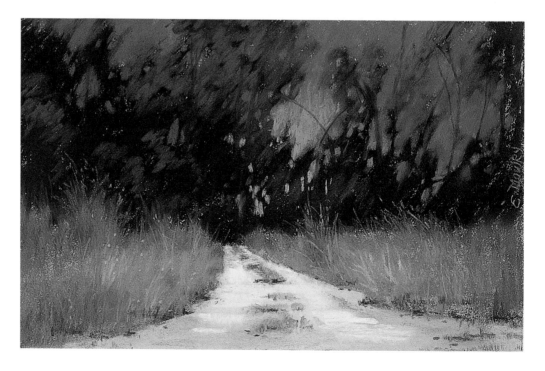

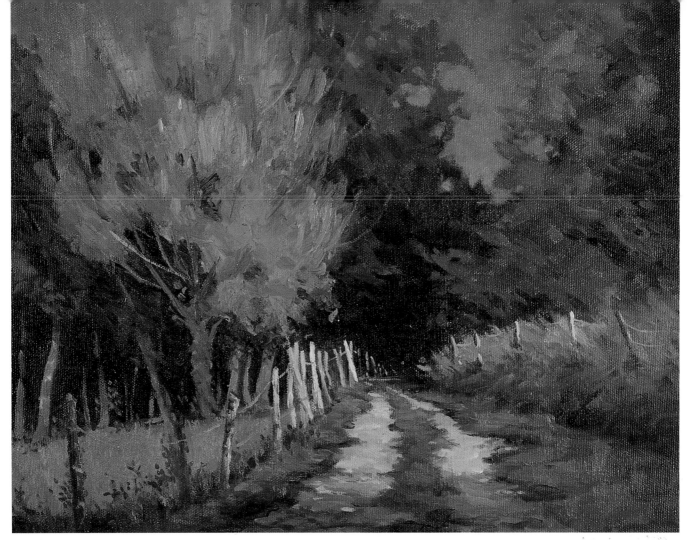

PRINCE WILLIAM'S WAY
Oil on canvas, 11" × 14", 2004

Personal meaning is an important element in our best work. Here, only a quiet road found its way onto my canvas even though an exquisite historic dwelling and gardens were nearby.

But even within that oxymoron sleeps a lesson: rather than touch lightly upon a host of ideas that compete for our energy and our thoughts, we make one choice at a time, and then run with it . . . as far as we can go.)

In effect, what we do as we travel about is assimilate visual material as well as ideas, and then sort through what has appealed to us, evaluate our present interest, assess our existing skills, and finally put paint to our conclusions. More often than not, over time we begin to see and feel a state of artistic *grace* emerge, as the motif surfaces again and again with variety enough to sustain the excitement of an ongoing project unconstrained by beginning and ending dates on a calendar.

**LANDSCAPE LINES,
PROVENCE**
Pastel on pastel card,
9" × 5", 2000

*A vertical, on-site study
that was completed in
the studio works because
the composition consists
of diagonal, vertical, and
horizontal shapes that
play off of one another.
The light value of the
road tells the eye where
to enter the scene.*

SUNFLOWER SENTINELS
Pastel on sanded paper,
25" × 30", 2004,
collection of Nancy
and Scott Sherr

*Here, painted with
the same palette as*
Landscape Lines,
Provence, *is a large
studio painting that
uses familiar landscape
components rearranged
into a horizontal format.*

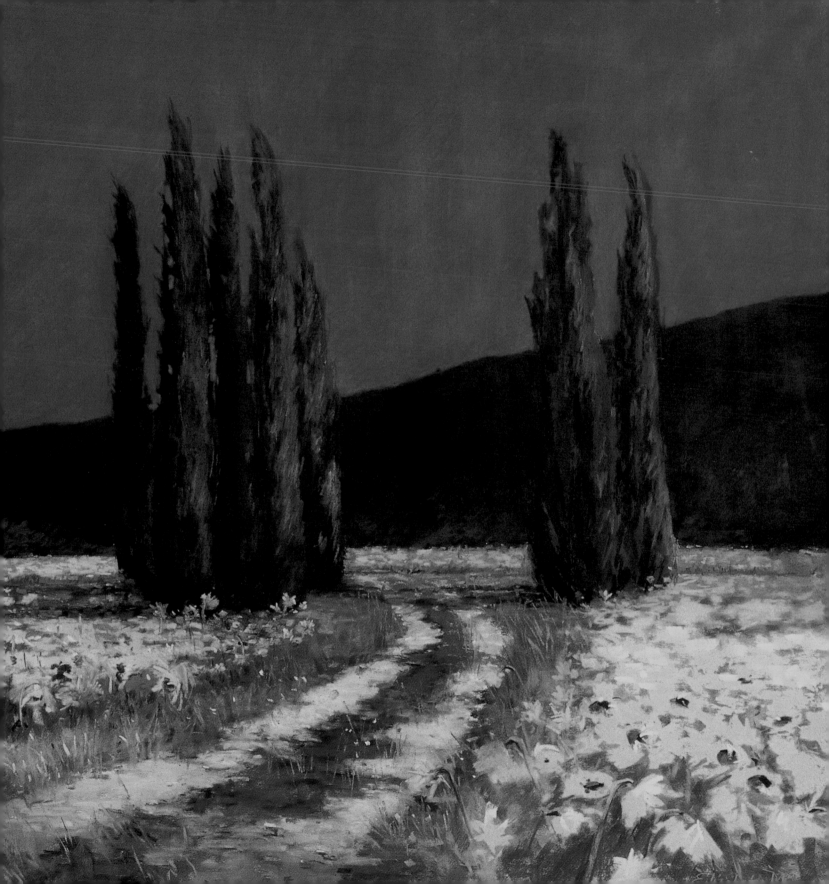

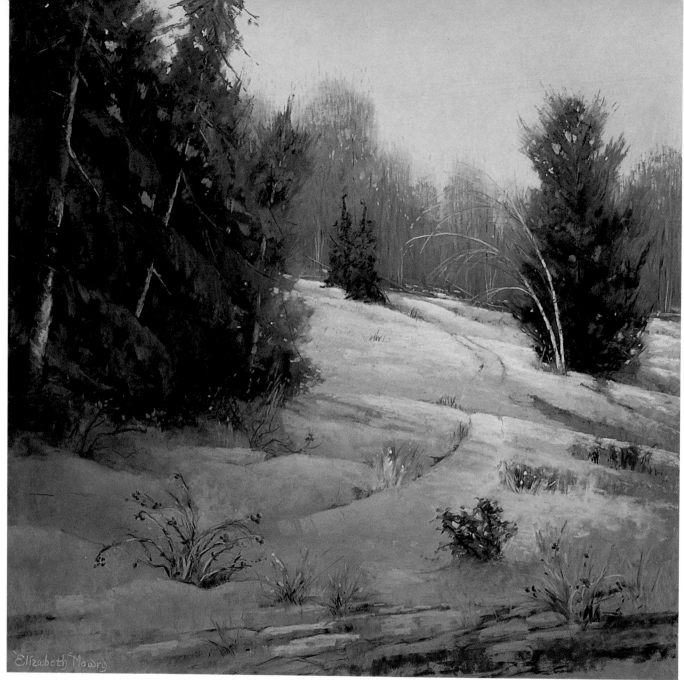

WINTER, # 4 OF SEASONS (DETAIL)
Pastel on mounted sanded paper, 24" × 24", 2002,
collection of Dr. and Mrs. Stephen Brockman, The Pain Center, Shelby, North Carolina

A yellow sky warms this scene of a footpath through the snow. Undulating compositional diagonals guide the viewer through the painting.

JANUARY MORNING
Oil on paper, 8" × 11", 2003

Winter is a breathtakingly beautiful season to spend time walking some of the "less traveled" roads and pathways with camera in hand, collecting painting material. Here a diagonal slice of sun shows the way.

SHEEP PATH
Pastel on sanded paper, 16" × 16", 2003, private collection

Animals create patterns through the landscape just as humans do. Here, in the distance, we can see a narrow sheep path winding up a steep hill toward a stand of trees at the top, where shade, an advantageous view of approaching predators, and perhaps a cool breeze provide a resting place.

Waterways

WHILE ROADWAYS AND PATHS through the landscape are made by humans or animals, waterways exist most often where nature has placed them. Recurring patterns of water that network their way through a landscape are versions of a theme that appeal to us largely on the basis of exquisite natural composition. We want to follow the pattern as perspective diminishes in scale from the foreground to the horizon and along any graceful departures along the way.

Water forms over the landscape have individual appeal. The tranquility of still water spreading itself in a mostly horizontal design has a different effect than the vertical path of a waterfall that spills noisily, or musically, from the top of a composition to the bottom. Forces of nature impact the vastly diverse patterns of water that flow over the landscape. Shimmering flood-waters under a setting sun or an eerie moon cast a different spell than the iridescent bubbles that circle and swirl in a fast-racing mountain stream in early spring.

Linear water patterns through a landscape provide one of the strongest visual elements of form that are so important to powerful composition. The eye is easily drawn into a painting by the linear form of a river or even a tiny winding rivulet that threads its way through the marsh, creating a recurring dialogue between plant species and reflecting, placid water. As we know, the longest linear patterns of landscape are along the seacoast, where land makes its transition to water. Sometimes this occurs gently through unfolding marshlands; other transitions are dramatically marked by rugged cliffs meeting thunderous, crashing waves.

CAPE COD MARSHLAND
Oil study on wood panel, 4" × 8", 1999

Marshlands present us with the opportunity to paint the water path in a way that invites the viewer to follow it to the horizon, with only minimal suggestions of where the water is. Sometimes less is more and even that is too much.

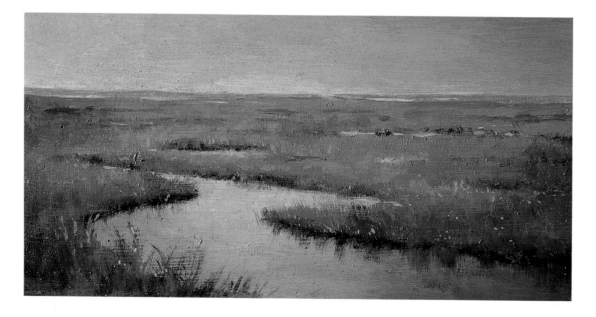

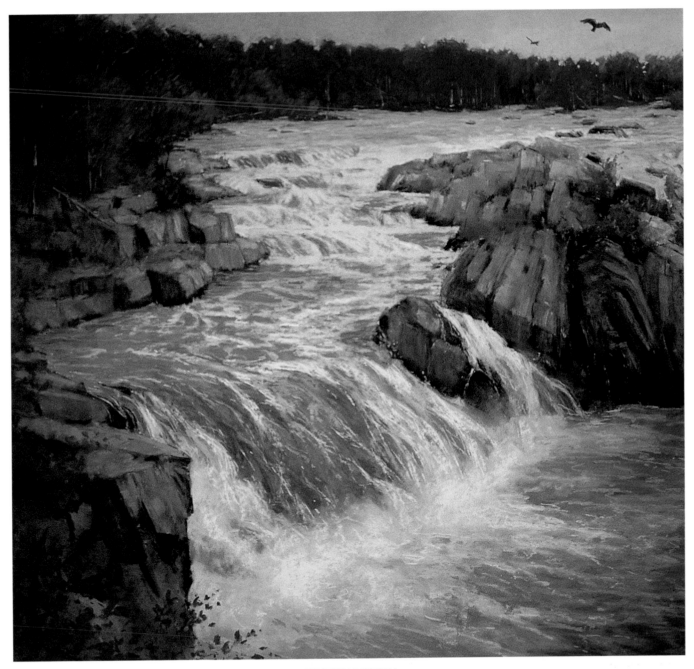

GREAT FALLS, VIRGINIA
Pastel on mounted sanded paper, 20" × 18", 2004

Compare this detailed, site-specific painting with Cape Cod Marshland. *Here the center of interest is the detail in the waterfall. Sometimes our reasons for doing a painting will determine how we paint it.*

above
RESERVOIR ICE I
Pastel on sanded paper, 12" × 16", 2000, collection of the artist

opposite
RESERVOIR ICE II
Pastel on sanded paper, 16" × 20", 2001, collection of Eva Van Rijn

These two paintings show how palette changes explore two vastly different color expressions of the same scene.

SUNSHINE AND SHADOWS
Oil on canvas, 18" × 24", 2003

The three paintings on these two pages could easily begin a subtheme: Water Paths in Winter. I hope you will be inspired to try some. In this closed-in, intimate peek at water as it meanders downstream in a leisurely manner, the sunlight tells the eye what areas are important.

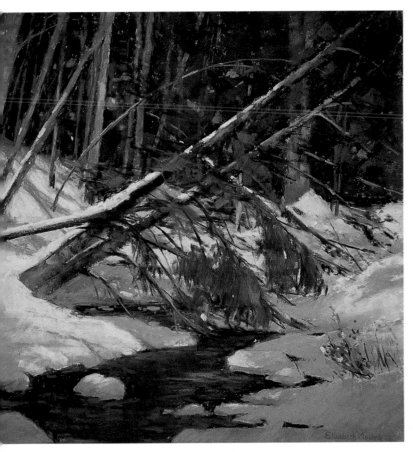

ALONG THE RAIL TRAIL, WINTER
Pastel on sanded paper,
16" × 16", 2003

Here fallen trees block the view of the narrow water path. Notice how the scene becomes quieter because the visible movement of the water is interrupted.

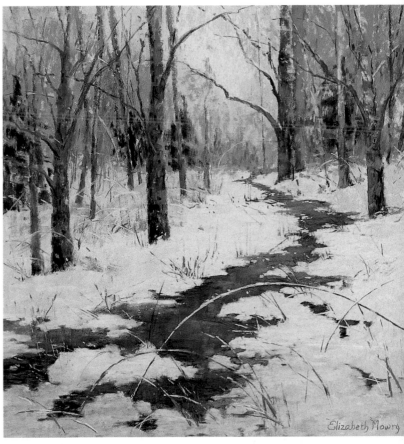

THROUGH WINTERSET MEADOW
Pastel on sanded paper,
16" × 16", 2003

A seasonal shallow stream creeps through the meadow behind Winterset, but in winter the lazy patterns it creates are pleasing. Placement of a water path on your surface is important because it determines, to a great extent, how the viewer will read the painting.

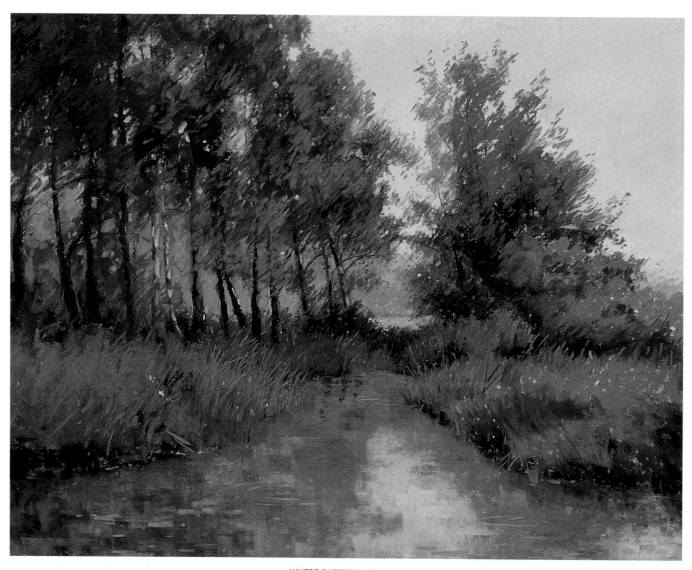

WHERE BUTTERFLIES PLAY
Pastel on mounted paper, 21" × 27", 2000, private collection

Water gently winds its way through an area of trees before it continues back toward open fields and sunshine. The subject is quiet, as is the palette that was selected to paint it.

Thoughts: Artist to Artist

ROADS, paths, and waterways can become a metaphor for life. Their existence defines what they are, showing us that others have traveled there before us and will travel again after us. They suggest a course taken or a line of movement. They also lead the viewer into the scene more quickly than if they did not exist. The observer will feel gently abandoned when a road or path curves provocatively behind trees or meanders over a hill and is no longer visible. The viewer thus becomes an active participant in the painting. At this point, the artist offers the pictured place to the beholder for reflection on memories based on his or her own experiences, so that connection with place becomes personal and meaningful.

Roads, paths, and waterways in paintings link us to a positive optimism of what is fresh and new, and beyond now. In a harried world where people are obsessed with accumulating more things, these themes stretch metaphorically toward a calmer, more meditative pace for every day. The painted dialogue passes from artist . . . to painting . . . to place . . . to viewer . . . and, through a mutual connection to that place, back to the artist.

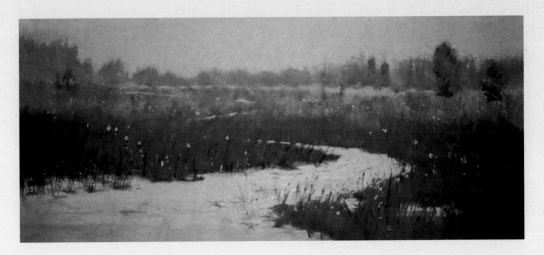

GOING HOME
Pastel on sanded paper,
7" × 16", 2000

This winter scene of the fields beyond my home is typical of where I live. Tractor paths through my neighbor's fields are favorite places for daily walks with my camera. It is not necessary to show the whole path in your paintings; the eye knows how to get to the horizon with the barest of elusive suggestions.

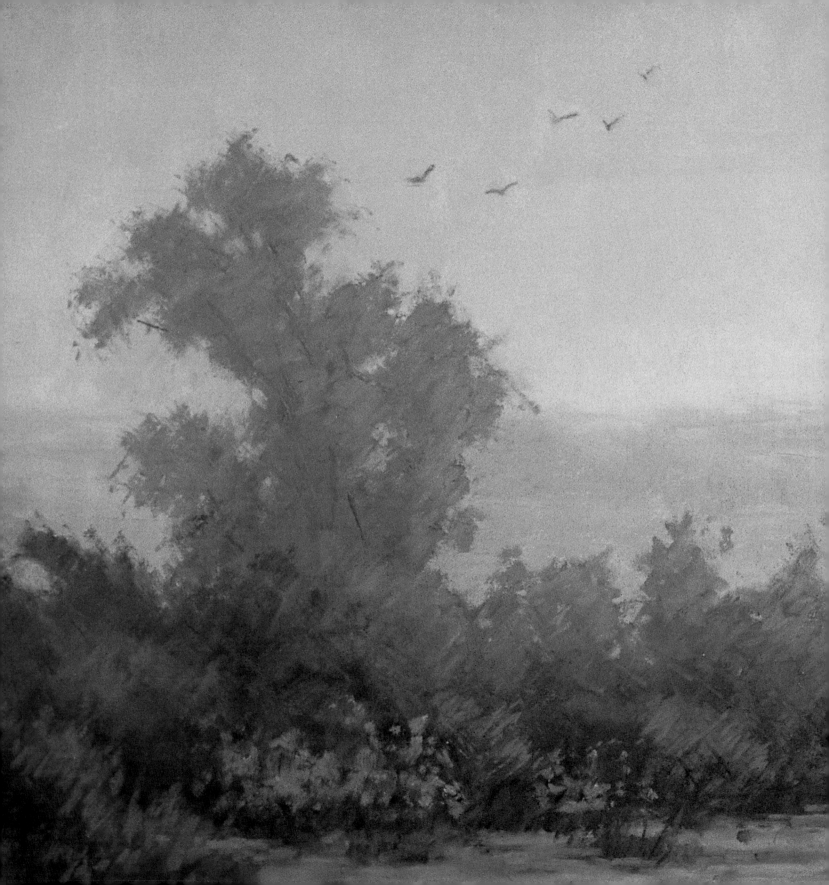

The Transient Subject

Mist and Haze

Now let's address the adventure of painting the transient subject. Mist and haze, examples of which are pictured here in varying degrees, are only several of many motifs that are not available all of the time to the landscape painter who selects them as themes. Subjects such as falling snow, windblown trees, apple blossoms, or rainwater that has flooded onto surrounding land in interesting designs are but a few that do not fit the scenario of prearranged outings by groups of painters for a particular date on the calendar of events.

Nature is a muse that will neither bow to an agenda nor be controlled by our schedules. Some of the most engaging subject matter may present itself only sporadically at best, so that a series of work about it may spread itself over months or even years—sometimes a lifetime—in which case we begin to regard it as simply a favorite subject that we return to as opportunities arise.

In the field of art, as with most things, there is a growing tendency to categorize everything so that in this world of overcommunication, it can be accessed easily. Creativity resists being boxed up. There are as many ways to approach doing what we do as there are reasons for doing it, and it is perfectly valid to select a motif (or several) without a beginning and end date in mind, or worse, a scheduled exhibition when the work is expected to be completed. Deadlines are deadly to the creative personality and to the work executed by it.

In order to paint the haze- or mist-drenched landscape, the most crucial prerequisite is an impeccable skill in using tonal values. Every plane within a misty or hazy painting must be carefully related to what is in front of and behind it. Sometimes you will need to adjust a favorite passage because the relationship

MORNING MIST
Pastel on sanded paper,
5" × 10", 2001

In this small study of horizontal and vertical landscape components, the value differences that occur between near and distant shapes become very important.

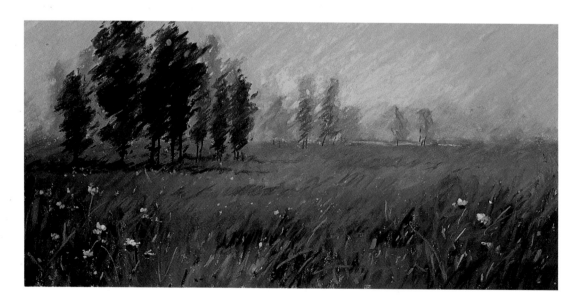

BECKONING VI
Pastel on pastel card, 6½" × 13", 2004

As we become more and more familiar with natural atmospheric conditions in the landscape, we begin to see more . . . more subtlety of color, more interplay of line and curve, and more nuance. This is especially true when the subject is extremely simple, whereas when the subject is complicated, the mind becomes busy processing additional information.

is not quite right. In paintings that include mist or hazy atmospheric perspective, it *must* be right. The subtleties involved are what determine the credibility of the painting, and the margin for error is small because at one extreme is a weak painting, and on the other a ludicrous painting—both failures.

Mist lingering over the landscape, or haze burning off of it, evoke a sense of mystery. Both diminish the competition among landscape shapes. The contours of most fragile shapes disappear. An example would be the edges of bushes or trees, where atmosphere peeks through. Other solidly structured shapes hold together. Natural forms also simplify themselves according to how near or far away they are. Accuracy of portrayal is what makes the misty or hazy landscape "readable" without sacrificing the illusion of mystery.

For me, the most surprising learning discovery that occurred as I painted misty and hazy landscapes was that the place of enchantment is not necessarily always in the foreground, where color is stronger and contrasts are greater. Generally we use stronger color,

higher contrast, and more detail to bring attention to the focal point in our painting. That is not the case when painting the hazy or misty landscape in which the haze or mist itself is the motif. Within that context, the eye will travel from the most obvious forms in the foreground of the painting, then begin searching for objects that can be distinguished in the middle ground, and finally search for where to go next until it reaches the area where forms disappear. In other words, the eye takes pleasure in going as far as it can and *that* becomes the *sanctified place of most intrigue*. It is where the painted story pauses and the viewer is invited to continue the script.

I discovered the silvery blue half-glow of mist years ago in France one very early dawn. I was so enthralled that I painted a series of paintings of the Epte (three of which are included here), striving for that elusive gloaming light that I had witnessed. Only after a time did I begin to recognize similar subtle qualities of tone in my own surroundings. Seeing cannot be forced. It happens when we are ready.

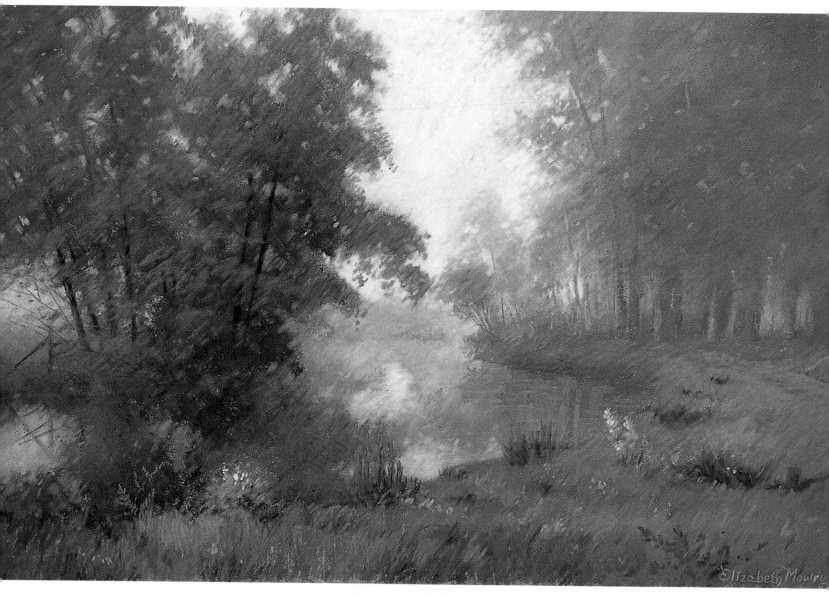

MORNING ALONG THE EPTE VII
Pastel on sanded paper, 16" × 25", 1996, collection of Annemie and Martin Janssen

Nature isn't all about sunshine. In my area, if I waited for the sun, I might not paint very often. I actually love the mood of an overcast, drizzly day. As Roger Miller put it, "Some people walk in the rain; others just get wet." All three of these paintings show the effects of heavy morning mist on a quiet landscape. As you can see, the palette is limited in color range. The value differences change very gradually and hold little color from the background through the middle ground of the paintings. Even in the foreground the additional color is not highly saturated. Sometimes I do a series of paintings simply to learn more about some aspect of nature that I want to understand better. In a sense, these become visual dissertations of place.

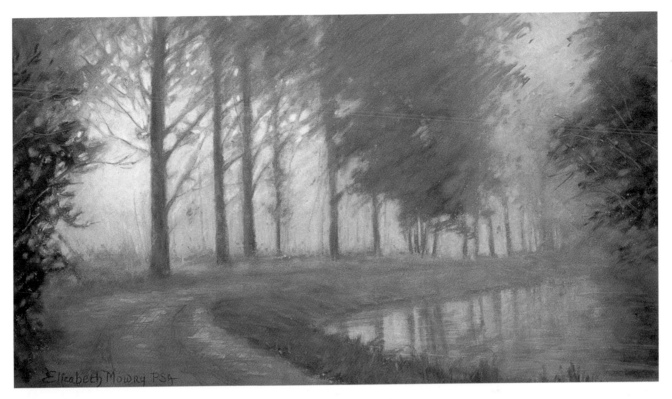

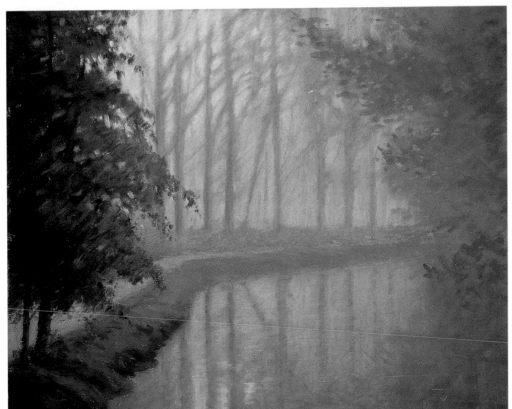

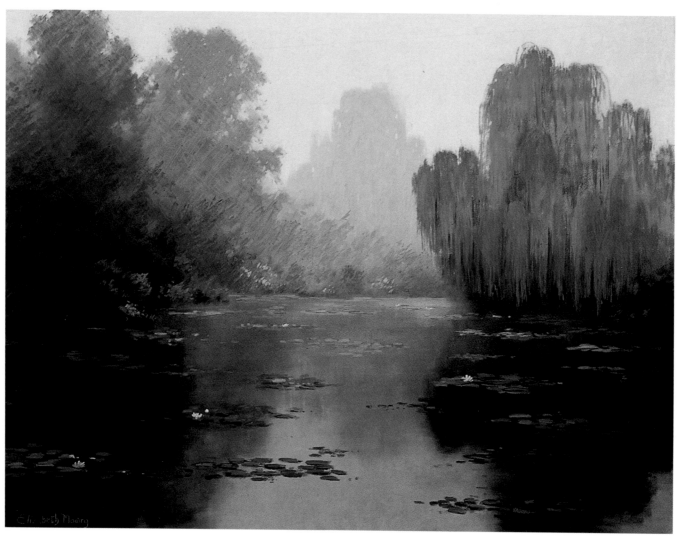

MONET'S WATER GARDEN
Pastel on mounted sanded paper, 18" × 24", 2000

In a misty atmosphere, still water will appear silvery. Here the horizontal pattern of the water lilies enhances the design of the willows reflected in the water without disturbing the quietness of the painting. Much of the detail was eliminated.

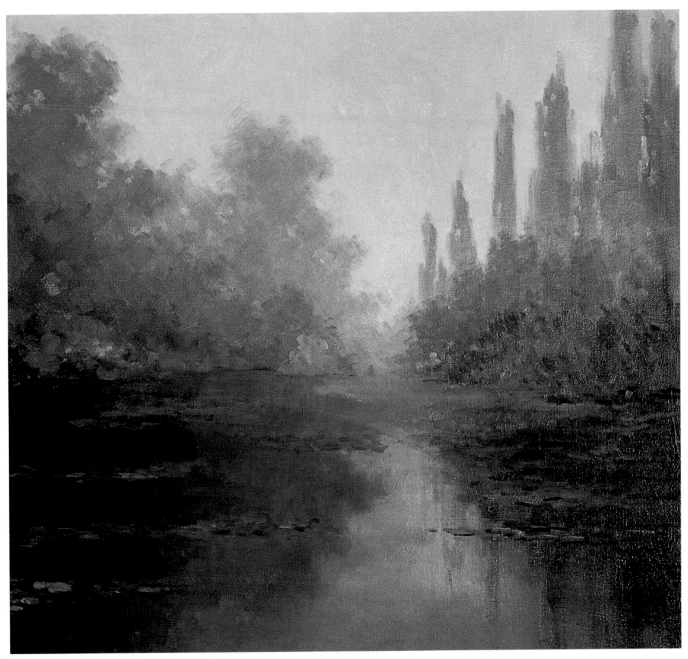

SILENT CONVERSATIONS
Oil on canvas, 20" × 20", 2004

The ability to paint very subtle value differences transfers easily from one medium to another. This oil painting has some of the same landscape elements as Monet's Water Garden, *but it was composed in the studio.*

HAZY RIVER, FRANCE
Pastel on sanded paper,
11" × 19", 2003

The quiet water catches reflections here as warm sunlight begins to burn off the morning haze. Color values are very near one another in the distance, and most of the edges throughout the painting are soft. The dominant sky colors on a misty or hazy day will affect the color of all other components in your landscape.

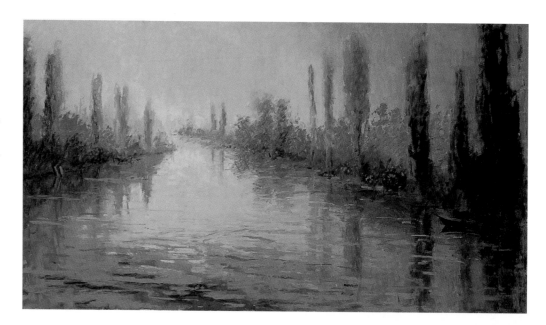

VIRGINIA MORNING
Pastel on mounted sanded paper,
16" × 16", 2001, collection of
Amy Squires

In this square-formatted composition, atmospheric perspective takes effect earlier in the progression from foreground to background than if it had been a clear day.

MORNING BURN OFF
Pastel on sanded paper, 16" × 24", 2002, private collection

The same scene as Virginia Morning *opens up horizontally here and the palette changes. A light frost had just disappeared from the grasses.*
The misty atmosphere drained the saturation of color from the scene as the sun appeared and began to burn off the dew.

MORNING, MAINE
Pastel on sanded paper, 18" × 24", 1997

Paths and dirt roads off a main highway are intriguing, because quite often after a short distance they disappear from view. Here early morning mist and overall low-chroma color convey a feeling of melancholy dusted with peace. The dropped cable hints that the road may lead to a popular fishing spot, or at any number of other stories for the viewer.

Thoughts: Artist to Artist

MONET BELIEVED that the perfect use of mystery was "to evoke an object little by little in order to reveal a state of mind. . . ."

Pursuit of subtlety is not for the weakhearted. It is frequently not understood by an onlooker whose knowledge of nature, or experience with it, is considerably less than your own. In competitions where slides are projected onto a screen quickly one after another, the button won't pause for subtlety as quickly as it will for explosive vibrancy.

Mist or haze over the landscape has been synonymous with mystery for me since childhood. Perhaps as compensation for poor eyesight, I had been gifted with an incredible imagination, which, being an only child, served me so well that I have no recollection of ever being lonely or bored. Whatever was not right in my small world, I made all beautiful in my mind's eye.

Distances become vague and there is a feel of slight disorientation when our surroundings aren't clear. I can recall ice skating alone in a flooded frozen field near my home after a temperature change caused a thick fog that lifted, moved, dispersed, and then formed somewhere else. I was ecstatic, skating wildly into the fog, chasing the thickest accumulations while unable to see the ground. The silly innocence that was a child's joy might have signaled what ultimately became a lifelong craving for solitude and also, in my painting, for the frequently softened edge, the lack of allover outline or closure, and a need to provide an invitation to the viewer to relate to my world. I still prefer the suggestion rather than the command, the hint rather than the "in-your-face" or overdone statement, and the choice rather than heavy-handed rules. Everyone's experiences differ and we need to pay attention to those differences rather than become homogenized, especially in our creative endeavors.

In the case of mist, if you wake up early and glance out of the window to see the mist hovering over your surroundings, you move. You know where your camera is, as well as your boots and your slicker. Breakfast and hairbrush wait. Living alone or with a partner who knows you very well is a bonus, because rationalizations are probably not possible for why you are departing from the garage in such a hurry with the edge of your nightgown flapping from beneath the car door. I am grateful that my own children are happily living their own set of adventures far enough away not to be embarrassed by a close association to the local "character," or worse, the neighborhood lunatic, too easily recognizable by the Wellington boots and the blue beret.

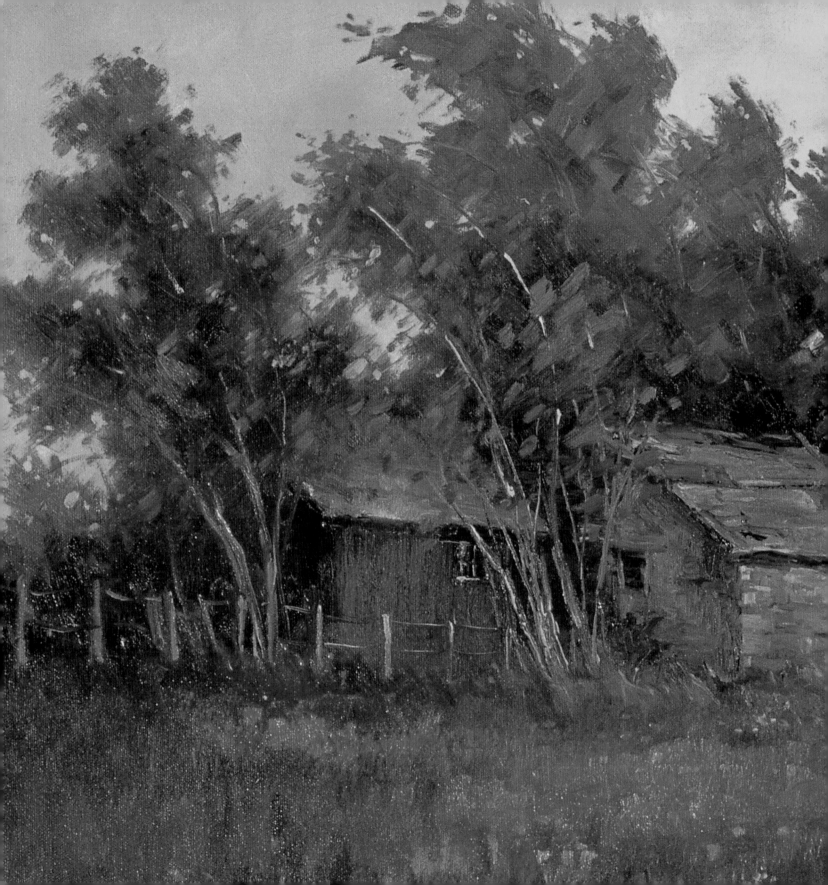

Motifs Reflecting Human Presence in the Landscape

Structure: More or Less

THE ABSENCE OF mankind's influence on nature has been a conscious and deliberate theme of much of my painting for many years, but as we come to terms with passages of inner turmoil, we let go of exclusive thinking. Now, I find myself experimenting in my work with the coexistence of mankind and nature, with the emphasis shifting from "presence or absence" to "degree." Within this altered viewpoint is a fascination with the idea of mystery surrounding the placement of structures in paintings. Lately, whenever I see an edge of a building or a roofline visible from an interesting place of its own within the landscape, I attempt to translate that onto the two-dimensional painting surface without going beyond the point of detail,

FRENCH VILLAGE
Pastel on sanded paper, 8" × 8", 2001, collection of Martha Singleton

This plein air painting of Castelfranc, a small village in France's Lot Valley, was begun with a group of painters on a sunny afternoon in summer, the ultimate experience for a landscape painter. Months later in the studio, I eliminated much of the detail and limited the area of greatest light to the graceful arches of the bridge. By bringing the values closer to one another everywhere else in the painting, those areas became less important than the place of highest contrast.

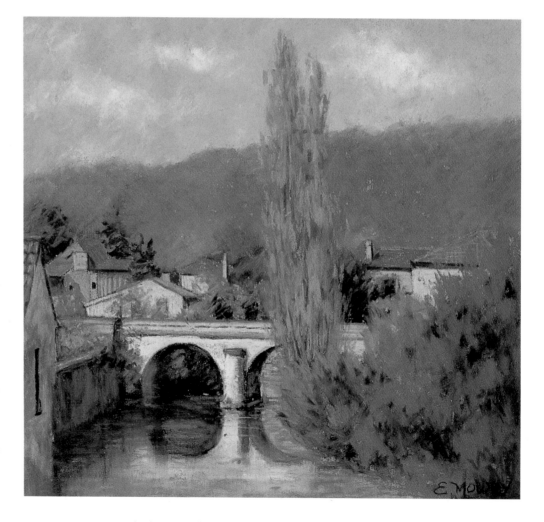

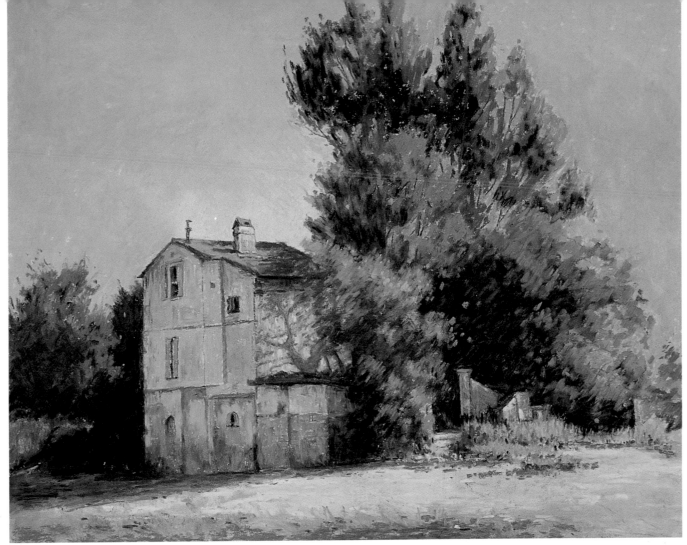

SOUTH OF ARLES
Pastel on panel, 11" × 13", 2000

Van Gogh painted his famous Langlis Bridge scene from this place near Arles in 1888. Several years ago, what began as a brief workshop bus stop photo opportunity was lengthened to an afternoon of painting when we saw all of the possibilities that existed. I painted a graceful stand of trees while there, but photographed this building for future reference. Even though almost an entire structure exists in the scene here, much of one's attention centers on the trees and the shadows they are throwing on the side of the building.

after which my interpretation would lose its mystery. It is like trying to say more with less about "relatedness," yet short of crossing over to where it would be impossible for anyone to relate. Courting that tenuous "edge" can be an interesting challenge. The painting captions in this chapter follow my thinking as I painted a village, then some buildings, a few outbuildings, some shadowy structures, an edge of a building, a few rooftops, a fence, and a church steeple. You will notice that the focus of the work included here gradually shifts away from the structures so that only hints of untold tales remain.

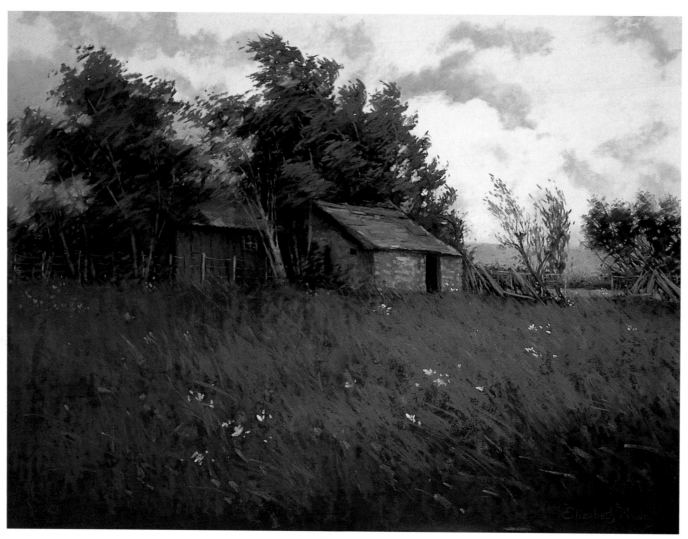

OUTBUILDINGS
Pastel on mounted sanded paper, 18" × 24", 2000

This is one of my favorite paintings because of the combination of the "degree of presence" of the outbuildings and, at the same time, the absence of conclusion. The mood is strongly felt in the movement of the clouds, trees, and grasses. I realize that personally I enjoy the challenge of an inconclusive "edge" in paintings. Four years later I painted the same subject (see detail of Kafka's Dream *on pages 80 and 81) in a different medium and with an intense palette, while still preserving the mystery of place. By wondering "if," I often create my own lessons and then try to follow through.*

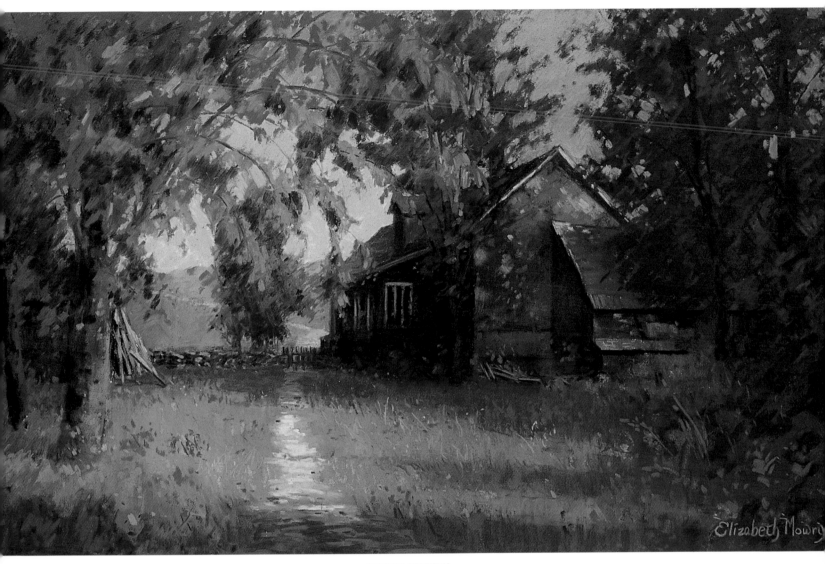

SUMMER SHADOWS
Pastel on panel, 12" × 20", 2003

Here the cool shadow areas of this summer painting become its most interesting feature. Structure will generally take precedence over nature in the eye of the viewer, and here the lines of the house determine that it is the focal point, however subtle. There is no need to show all the details of the house or of the distracting items piled up against the foundation. Elimination of those details makes an intriguing story rather than a site-specific representation.

right
SAINT FRANCIS' VIEW, ASSISI
Pastel on sanded paper, 11" × 7", 2001

This small study was painted at the site of the grotto of Saint Francis, high above the town. Time was limited and there were many tourists on pilgrimage. Sometimes the bustling activity of popular places can be distracting. Painting the view with only a few foreground rooflines provided me with the memorable experience of place without any more specifics of the scene than I needed.

below
BEYOND THE WALL
Pastel on sanded paper,
10" × 18", 2000, collection of Connie and Emmanuel Gerondaras

Visible here beyond the trees and the stone wall is only a small portion of St. Paul's Maison de Sante near St. Rémy, where Van Gogh spent some time. Although the scene holds lovely personal memories, most viewers will be able to relate because there is not enough of the building pictured to be site-specific.

SANTA FE FENCE
Pastel on sanded paper, 8" × 7", 2001

CHURCH TOWER AT BRISSAC
Pastel on sanded paper, 9¹/₂" × 8", 2003

One day I spent a quiet afternoon walking and sketching in the outlying areas of Santa Fe. I was attracted to the simplicity of materials and construction of these handmade fences, which are everywhere. Here a dialogue exists between the corner of a formal adobe wall and the rustic fence. We might be inclined to assume that the simplicity of this subject would imply mystery, but here it does not, reasons being that the fence is in an open sunlit space and is less intriguing than the entire house shadowed by trees in the painting Summer Shadows.

As I walked to the pâtisserie in the lovely little French village of Brissac, I heard steeple bells ringing. Through the trees, I could see the tower reflecting the morning sunlight, a beautiful memory without the complication of "more than enough."

motifs reflecting human presence in the landscape

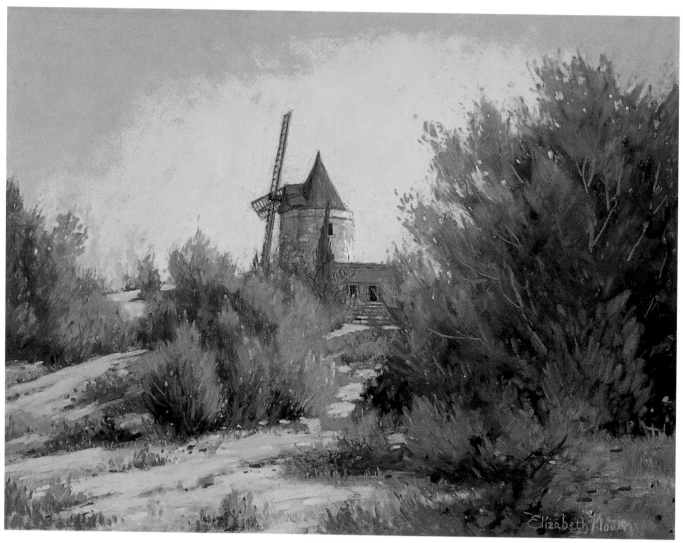

DAUDET'S MILL
Pastel on sanded paper, 10" x 13", 2000

It is believed that the French writer Alphonse Daudet wrote his Lettres de Mon Moulin *at this mill in Fontvieille, southern France. Although one can walk up to the windmill, I liked this view from farther away, where I enjoyed a picnic lunch with other painters and watched the summer sunshine pour itself over the dry earth. There is no question about where and what this is, but I felt that the setting was just as important to the painting as the mill itself.*

Thoughts: Artist to Artist

FLEXIBILITY IS a prime consideration when you choose a theme. Pay attention to what attracts you. Motivation will always be stronger when the subject of your work is a personal choice rather than a workshop stop based on bus accommodation, where you file out, collect your gear, and begin to paint. Sometimes several painting motifs may coexist, and as you view the surroundings in your immediate area or on your distant travels, your eye will gravitate toward scenes that would find a place within work already completed. The work included in this chapter has been done sporadically. When you have favorite subjects, you will add to your repertoire of subject material as you travel. You *know* when you see your motifs because your mind's "storage file" is already open and waiting. At other times you may begin a new series, stay focused, and take it to completion within a season.

GERONIMO'S DOORWAY
Pastel on sanded paper, 11" × 15", 2001, collection of Frank E. Davis, Jr.

This is actually the kitchen entrance at the side of a famous restaurant in Santa Fe. I frequently photograph interesting doorways and windows. Sometimes they are fun to paint as well.

motifs reflecting human presence in the landscape

People in the Landscape: Anonymity

I HAVE ALWAYS BEEN IN AWE of those tiny bending figures tucked into the paintings of Jean-Baptist Camille Corot, George Inness, and Ivan Shishkin, sometimes so small that just by their presence in a landscape the willowy trees appear taller, the sky grander, and the hills more distant. These three poets of landscape were proclaiming the magnificence of nature when they applied tiny blue, white, or orange brushmarks to suggest a man's workshirt or a woman's skirt and kerchief.

As a child I bonded more easily with nature than with people, and now I am rediscovering and welcoming that intensely significant connection. However, it is with profound appreciation of my family, dear friends, and all the people who make my life beautiful that I acknowledge evidence of human presence in some of my landscapes. Nevertheless, when a figure is included, it is not identifiable. Landscape that includes the human figure is more poetic, as I see it, if it represents a timeless condition such as working in the fields or a garden, walking as people do to think through a situation, or sitting quietly. Conversely, when the human figure in a landscape is identifiable, the complexity and specificity inherent in every human identity assumes priority, and nature becomes secondary. Think about viewing a photograph of someone on vacation. First you

NEAR ÉTRETAT
Pastel on sanded paper,
5" × 7", 1997, collection
of Monsieur and
Mme. Jeanmaire

A young man sits alone, thoughtfully, on a hill. The figure freezes the scale into place. The condition is quiet, nonactive, and without closure, but nearly everyone can relate to this image.

**POUR MA FEMME
(FOR MY WIFE)**
Pastel on mounted
sanded paper, 18" × 18",
2000, private collection

*While on a morning
walk, an elderly
man has picked a
few wild poppies
for his wife. A
lengthy explanation
here would detract
from the impact of
the painting. The
artist extends a
generous gesture to
the observer by
inviting him or her
to finish the story.*

determine who it is, and only after that do you notice where they are. Human beings are alive and active; nature is alive as well but on such a grand scale that it appears quiet and passive. Given some thought, we realize how extremely difficult it would be to paint the specific facial features of an identifiable figure in a landscape and attempt to keep nature more important.

In the images shown here, the human presence is indicated by figures that are painted either small or turned away from the observer. By remaining anonymous, they represent a type or condition of the individual pictured. Within the scope of this book and the concept of landscape painting, to me, nature is primary.

Because my own experience of drawing and painting the figure with expression is limited, I wish to share with you two magnificent figure drawings of Deane Keller, instructor for many years at the prestigious Lyme Academy. These drawings are powerful not only in execution but in impact, because the figure itself transcends the facial features, which are purposely obscure. Though not set within a natural landscape, they are eloquent examples of anonymity, the idea of which is important for the landscape artist to study and to understand, because within the painted landscape that includes the human figure, it is gesture that will prevail. The figure suggested must be easily related to by everyone. Deane Keller's drawings pictured here pay homage to the beauty of all humanity. Through such drawings we witness human conditions such as pathos, resolve, rest, concern, sorrow, strength, and acquiescence. The drapery on some of the figures hints at a particular culture. The gestures speak to us of the emotions. There is no need for more.

right
Deane G. Keller
DRAPERY STUDY
Charcoal, 24" × 18"

far right
Deane G. Keller
FIGURE STUDY,
CAIRO
Charcoal, 60" × 34"

Thoughts: Artist to Artist

THERE ARE many reasons why a motif might wrap itself around one's mind and beg unrelentingly to be expressed. Though we are artists, we are individuals as well, with genes and past experiences that differ from those of anyone else. We can therefore choreograph our own dance around our selected theme and we can change the steps whenever or however often we wish, or we can eliminate the steps altogether and simply "sway," in which case the work may become abstracted. I share my thoughts on these topics by calling on my own experiences, my mistakes, and my discoveries. There are reasons for painting the figure in the landscape, and there are revered artists such as HongNian Zhang who do it flawlessly. What can be very gratifying is when we approach the subject with as much thought as brushwork, and consequently have a cohesive idea in place around which to obsess. One might guess that Cézanne's series of bathers revolved around a strong idea that kept providing more and more intriguing possibilities. Frank Benson's beautiful female figures, in white dresses with blue ribbons that caught the sunlight, also come to mind. Many were his family members, but painted in such a way that they remain unforgettably timeless.

From the broad comprehensive idea of the figure in the landscape, one may define many other specific avenues of exploration to pursue. Examples that come to mind include artists painting in the distance, women at the clothesline, pickers taking the harvest from fruit trees, or small groups of people enjoying a picnic or gathered around the dim light of a campfire. The possibilities for cohesive themes are endless for an artist who can strike a working balance between creative flexibility and steadfast focus.

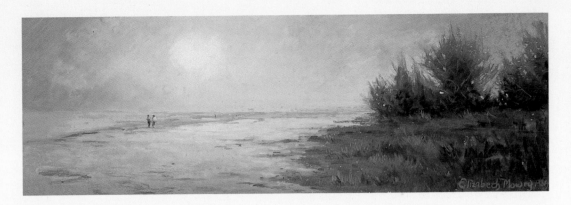

SANIBEL SOLITAIRE
Pastel on panel, 5" × 12", 1997, collection of Frank E. Davis, Jr.

Who among us has not walked on a beach, thinking, collecting shells, needing to be "far from the madding crowd" in order to sort out not the shells we picked from the sand, but life.

motifs reflecting human presence in the landscape

Learning and Theme Painting

An Expansive Motif

A ROSE WAS A ROSE to Gertrude Stein, but all landscape painters know that a tree is not just a tree. Early on, it behooves the painter of nature to recognize trees as compositional *friends*. Trees, more than any other landscape components, are most easily moved about, grouped, separated, made proportionately larger or smaller, featured, subdued, and added to or subtracted from the composition without dire consequences.

The word *friend* implies someone we know well, whom we can count on to be there when we need help; in return, we respect a friend to such a degree that we do not abuse the friendship. In landscape painting, trees are our *big* friends. Wildflowers, fences, clouds, and rocks are little friends, no denying. But trees are the big ones, the serious, over a cup of tea, "What can we do here to fix this?" kind. With trees, as with friends, we invest the time it takes to know about them.

In nearly every book about trees, we are reminded that all species have distinct personalities or characteristics. This is one hundred percent true, but it reads like a cliché and registers as one, and we don't really give the idea a whole lot of thought beyond that. Learning the characteristics of hundreds of trees would be a daunting undertaking, to say the least. It might be a bit more gratifying to think about "gesture." What is the tree doing? It *is* alive, you know. True, it could be just standing there, waiting. It might even be whispering, in French no less, "Je suis très, très content." But, in truth, many trees are stretching, bending,

twirling, pushing into the wind or turning away from it, peeking, struggling, bowing, reaching, drooping, even weeping. Trees may be healthy or diseased, hopeful or desolate. Some are old and gnarled and broken. Others are wispy and blithe. Some are left for dead, but throwing out young shoots, unwilling to die, and when conditions become unkind and they are tired, they do die. They are like us.

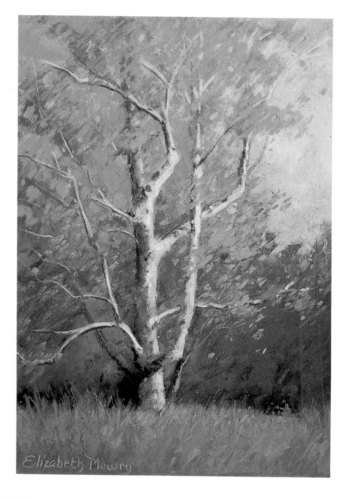

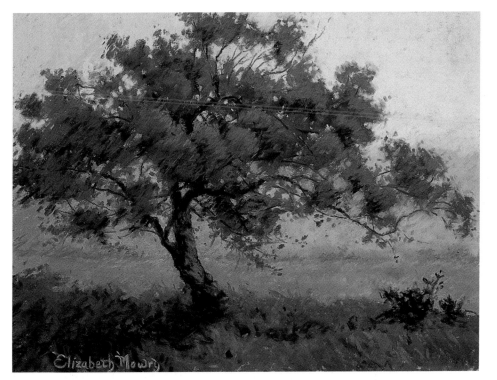

TREE, AKAROA, NEW ZEALAND
Pastel on pastel card,
8" × 10" sketchbook page, 2002

This lovely tree was actually in a very complicated setting, so I transplanted it in my pastel sketch. By painting a simplified background, the graceful reach of the branches becomes primary.

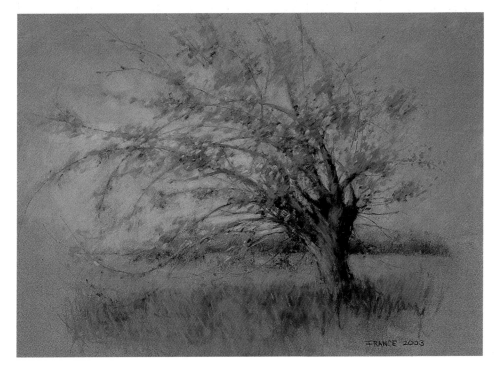

left
WILLOW
Pastel on pastel card,
12" × 16" sketchbook page, 2003

For field sketches like this one, when you do not have a great deal of time at a place, try for the tree's gesture. This tree was far more graceful than my efforts show, but I was able to portray some of the directional lilt of the branches and record the sparse leaf distribution.

opposite
THE SYCAMORE
Pastel on panel, 10" × 8", 2000

The erratic limb directions and the mottled bark of the sycamore are interesting features of this species.

Tree Portraits

WHEN WE FOCUS ON drawing or painting a single tree, we learn about conveying volume of foliage masses using subtle value changes. We begin to see patterns in the way foliage groups arrange themselves and in the size relationships of branches to trunk and in branch departure from the trunk. We recognize that sky holes arrange themselves between the large foliage groups, rather than just anywhere. Each tree does have its own characteristics that distinguish its unique personality. When we begin to notice and then understand this, we acquire a greater latitude of expressiveness as we move trees and groups of trees from one place to another to enhance our compositions, and we do it with confidence.

Trees can be elusive. Drawing them is an excellent method of honing our skills; it forces us to concentrate on accuracy. You do not need to know the botanical name of a species, but pay attention to its unique visual characteristics. Note the gradual taper from trunk to apex, or high point of the treetop, the meandering patterns of the branches after they depart from the trunk, the curve or straightness of the spine, and the edge patterns of the tree, where some texture detail can be seen. Modeling the foliage masses and placing them appropriately is a lesson in itself. Sky holes constitute another lesson. And, once you can see gesture, you will paint an expressive tree. Your tree will never be *just any tree.*

TREE, WINTERSET
Pastel on sanded paper,
8" × 10" sketchbook page, 2003

I used pastels to sketch this tree from my studio window the morning after a heavy snowfall. Low sun from the east lit the snow on the bowing branches before they lifted within a few hours as the weight of the snow melted and fell away.

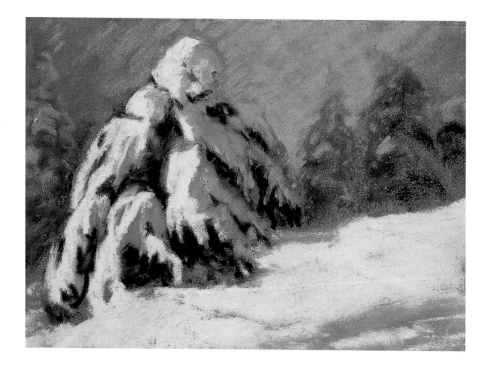

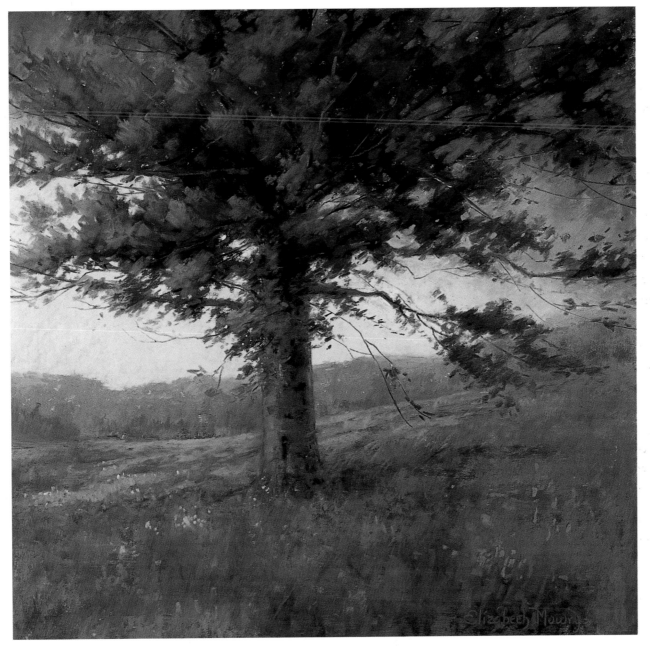

THE OAK
Pastel on sanded paper, 16" × 16", 1999,
collection of Andrea Sullivan

This stately oak, in its centered position, presides over the landscape. The rusty-hued autumn foliage and the complementary sky are close in value, which keeps the viewer's eye from moving out of the top of the painting.

above
TOGETHER
Pastel on pastel card, 12" × 11", 1997, private collection

This painting is actually of two trees that try to read as one. It is my choice of a transitional painting between tree portraits and tree bouquets. The shape of the tree foliage against thick Normandy mist was what stopped me in my tracks while on a hurried morning walk, long enough to take a photograph. One can almost feel the protective gesture of the larger tree toward the younger one.

left
EVENSONG
Oil on canvas, 18" × 24", 2004

This favorite tree appears in several of my pastel landscapes. It dominates this oil painting composition in which everything else is subordinate. I was experimenting with glazes at the time this was painted.

Tree Bouquets

AFTER LEARNING the characteristics of single trees by painting tree portraits, you will begin to develop a keen eye for appealing groups of trees. Then, again, notice what the trees are *doing*. They might be gossiping, or dancing, or waiting in line, or hugging, or supporting one another. You will start to recognize the difference between spacing among trees that is pleasing as opposed to dull distribution. Knowing that trees successfully adapt to the forces of weather, you will create your groupings so as to give direction to the painting and to the eye of the viewer.

Sometimes a remarkable painting can be simply about a group of trees, or a tree *bouquet*. Trees, like ballerinas on a stage, can be the star as in a tree portrait, part of the supporting cast as in a tree bouquet, or the chorus line or concert as in a tree line or a forest. Placement on your painting surface becomes critical here, and you learn about compositional rhythm by moving tree groups around in your sketches, or by changes you control through your camera lens. There may be many possibilities, and you must ask yourself which are most pleasing, and then think about why. This is a huge step forward when painting the natural landscape. You see how the trees relate to one another in a group. Shape is the key. Take the time you need to get it correct. When you paint woodland scenes, they will be stronger and have more sculptural character because of all that you have learned about single trees and tree groups. You will know what is important because what you see will be grounded in what you have learned. You will know what to look

for and how to double check your own work for flaws, such as confused light direction or faulty proportion. When the scene is of dense woodland, you will remember to place enough dark value near the ground, where the foliage is thickest. You will ask, "Have I suggested the branches coming toward me as well as those going out from the sides of the trunks? Is the detail at the edges of the tree enough, or too much and therefore too distracting? Am I seeing an expressive tree or a huge collection of leaves? Is the lean of the tree consistent with the suggested wind direction of the clouds and the grasses?" You would always check this in a painting with clothes on a clothesline, but one may not think of it in a landscape made up only of natural components.

You might want to narrow your theme to a certain kind of tree, and then create compositions based on your own vision. You will be able to see how distance creates atmospheric perspective, size differences, color changes, and softened edges; how repetition creates a formal line; how careful attention to values can hold a painting together; and how suggestion versus detail, size relationships, and the handling of space will either invite or discourage the viewer.

When old fields are cut down to the edge of a wall, causing a single row of trees to be left standing, very often there will be vines that have grown undisturbed up into the trees, looking for light to sustain them. Corot's trees with draping vines were not just of his time. Shapes and patterns in nature repeat themselves over and over.

above
CHILLINGHAM SHEEP
Pastel on sanded paper, 12" × 12", 1999, private collection

Here the tree grouping becomes more concentrated, but because the scene is at the crest of a hill, the shapes and spacing of the trunks are defined. Landscape in Scotland without sheep would be difficult to find; these living props also invariably arrange themselves in an aesthetically pleasing manner.

top left
WICKET'S WAY, NEW ZEALAND
Oil on canvas, 12" × 9", 2002, collection of Jennifer and Antony Hayward

Eucalyptus, a species uncommon in my area, continues to fascinate me. The size, grace, and coloration of trunk and leaves add up to a grand style that is not easily overlooked. Wicket was a sweet dog who led me on long walks each morning past this stand of trees, through yellow gorse and other interesting, wet places.

left
LOFTY SENTINELS
Pastel on sanded paper, 13" × 10", 2003, collection of Jennifer and Antony Hayward

I believe it would be accurate to write that plant life grows rapidly in New Zealand due to the climate. Here the trees stretch toward the sky; even without people or animals in the foreground we can easily read the scale.

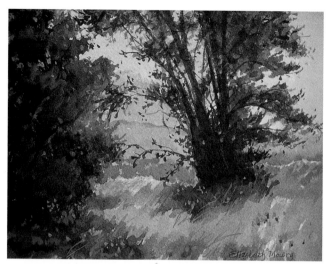

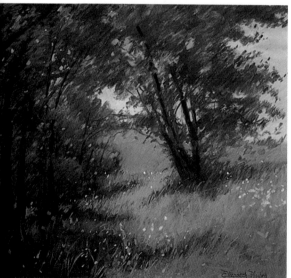

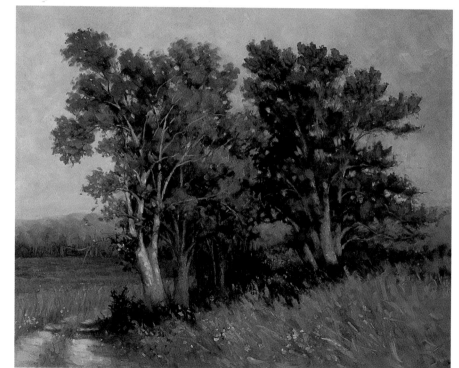

Sometimes we are overwhelmed and haunted
by a place that will not dismiss itself from
our thoughts. This was one of those places.
I did a small 10" × 10" pastel (top left),
a 5" × 7" watercolor detail (top right), an
11" × 13" pastel detail (bottom left), and
a large 24" × 30" oil on canvas (bottom
right) before I finally was able to put essence
to the place in this translation (opposite).

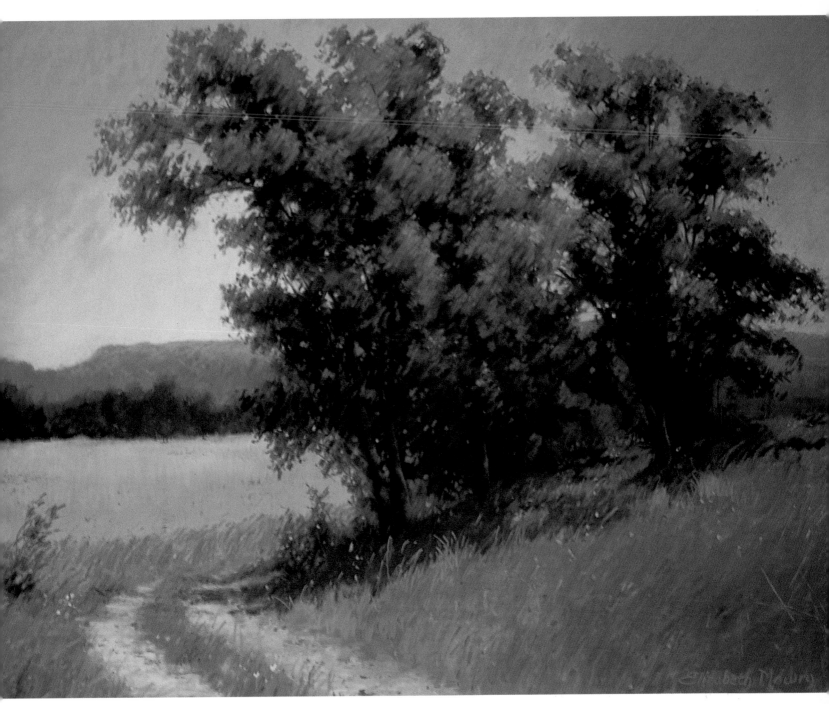

FRENCH BOUQUET
Pastel on mounted sanded paper, 24" × 30", 2002, collection of Lili and James Warnot, Jr.

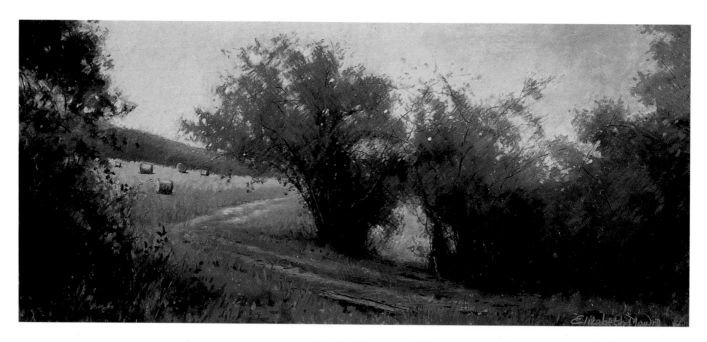

above
BRISSAC HAYSTACKS
Pastel on sanded paper, 12" × 25", 2004

"Bouquets" of bushes or shrubs as well as trees compose themselves in interesting shapes. Foliage, then, is generally delicate and airy. These young trees at the entrance to a hayfield serve as an example.

right
TREES, ROUSSILLON
Pastel on sanded paper, 8" × 10" sketchbook page, 2000

This demonstration was painted on location with several students painting along with me. It was a perfect subject for a short painting time. The multidirectional trunks and the light on the natural red rock formation and green pine made a complementary, interesting study.

Thoughts: Artist to Artist

PURE LANDSCAPE is difficult to compose and paint for those who have not had ample opportunities to know it and to feel it. Sometimes during the years when I was teaching, our workshop bus would stop in the countryside. I would look for interesting tree shapes, the negative spaces they created along the skyline, shadow forms created by them, or a graceful line within a tree that may have been created by the elements. I have overheard whispered rumblings by dear students who appeared to be in physical pain as, wide-eyed, they slowly turned in a 360-degree circle. I could piece together partially mumbled whispers such as, "Why did we stop here?", "What is she looking at?", and "There's nothing to paint." Then silence.

When a theme is expansive and requires expertise, it is sometimes helpful to backtrack a bit and be sure that we have the prerequisites to understanding a large-scale motif. Some discoveries occur in steps. We may not be ready to see some things until we learn about others. Natural landscape can be confusing to those who lack the means of *reading* it. They like it, they feel good in it, and they desperately want to paint it, but they will predictably gravitate to some kind of structure to anchor them when they paint it, whether a barn, a house, a bridge, or even a fence. They understandably focus on something they can relate to. In addition, when we lack expertise in an area, some cruel operative overtakes reasoning and we add more and more things as if they will diffuse or even erase what baffles us. At this point, the instructor notices stone walls beginning to meander through the fields in the class paintings, barns perched on hilltops with a few "afterthought" strokes, and sheep and chickens beginning to multiply in the foregrounds until the very brushstrokes that are adding things are actually wiping out every and any chance for a focused composition.

A better solution is to assess the area of unresolved landscape and separate the parts. Aside from the terrain of the land itself, trees are one of the more important components of the natural landscape. Before we learn to paint the woodlands or the forest, it is helpful, as with most things, to learn about the trees that are in it. Trees are just one example of a subject broad enough for the direction of the project to be pushed in many directions, and yet narrow enough for important learning to occur.

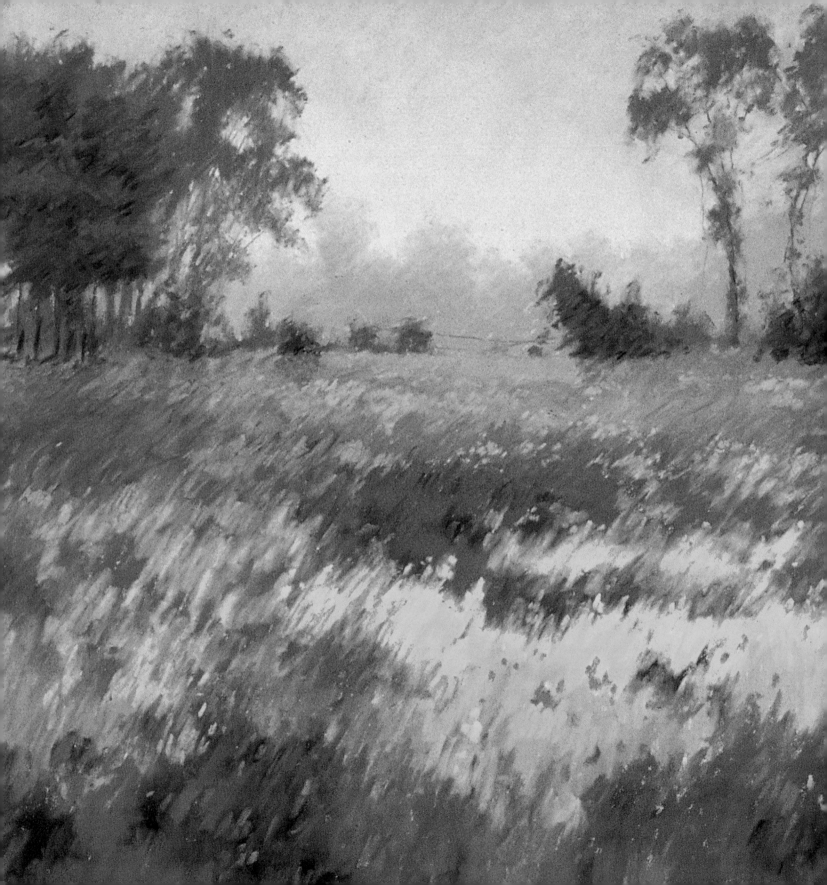

Exploration
of Place

The Field

IT WAS Eugène Delacroix (1798–1863) who wrote about the works by men of genius being inspired by "their obsession with the idea that what has already been said is still not enough."

Landscape painting explorations might consist of as few as two paintings with differences as straightforward as summer, then winter, or cloudy, then sunny. On the other hand, when connection with our subject grows into an exclusively magical obsession, we acknowledge that love for a place with an outpouring of work as we follow the muse. *The Field* is an example of a motif that sustained itself over a period of approximately a year. The series consists of twenty-six pastel paintings of the same field ranging in size from $3\frac{1}{2} \times 4\frac{1}{2}$ inches to 16×46 inches, some of which are pictured here.

The Field is a real place within two miles of my home. Over the past twenty-five years I have driven past it twice weekly on my way to and from the nearest village. One recent spring after some clearing of trees had been done near the road, breathtaking masses of white, purple, and pink wild phlox caught my eye as my foot simultaneously lowered the brake pedal to the car floor. At that very instant a painting motif was already claiming space in my mind. All I had to do was begin the first painting for the ideas to flow with the same abundance as the flowers that were growing among the grasses in the field.

Pictured here is the photo of the field as it appeared on that morning. The profusion of wild phlox was the initial attraction that excited me. I painted one painting, then another, and another. Before long, I realized that something else was becoming even more important. Beyond the field of flowers another field had been cleared, but along the stone wall between them only a few trees were left standing, now without the support of any others. Two of the trees seemed to be leaning into one another. In my paintings, those embracing trees always were included. They became the icon for the series of work . . . the constant as everything else moved, shifted, or changed as I explored color, shapes, and edges in my compositions.

At first we paint the obvious reality of the scene that initially attracts us. As we become more and more familiar with the landscape components we are working with in the same subject matter, we pursue other areas of challenge. We might introduce creative color, make compositional adjustments, or evaluate and refine the changing moods, seasons, and times of day in our paintings. In *The Field*, I eventually explored all of those areas, but particularly the possibilities of color

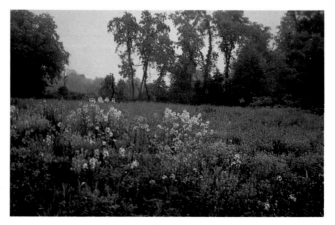

PHOTOGRAPH OF THE FIELD

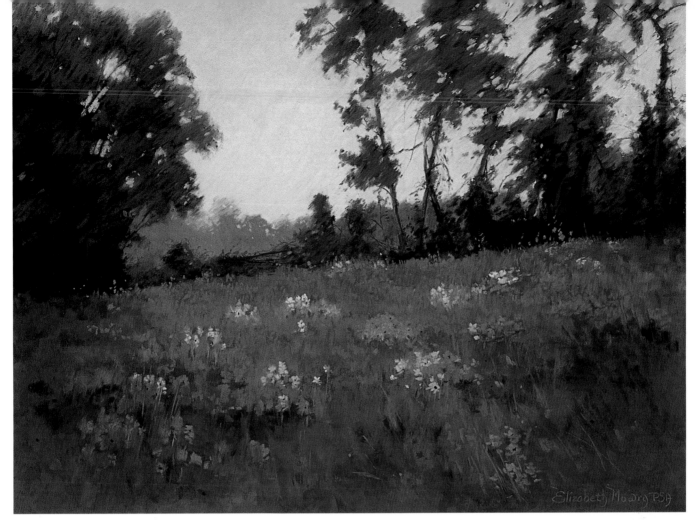

THE FIELD A

Pastel on mounted sanded paper, 18" × 24", 2001, collection of Cathrine and Thomas Pacini

This painting closely represents the actual field as it appeared when I noticed the abundant spring flowers for the first time.

that began to surface as I stayed with my theme and gradually moved from local color to "pushed" color, "restrained" color, "drained" color, and back toward selective vibrant color. My goal was to attain color unity within each image regardless of whether I was painting with a strong or soft palette. I worked out each color idea separately, aiming for both clarity of idea and harmony of color. On several occasions, it became unmistakably obvious that the sublime had become ridiculous on my painting surface, and I had to face my limitations head-on. Consequently, and humbly, I learned more about subtlety of color and edge, about choice and scope of subject, and about whether to include or exclude detail. As I painted the field many times, I also became comfortable with moving the landscape components around, and consciously directing the eye to a particular part of the image. Finally, having resolved composition, palette selection, and technique, my mind was free to emotionally explore the motif on an ethereal level in the final images.

THE FIELD B
Pastel on mounted sanded paper,
18" × 24", 2001, collection of
Betty and David Wall

Within the same week I painted the field a second time. Atmospheric perspective of a misty morning quiets the tree line and, at the same time, enhances the proliferation of flowers.

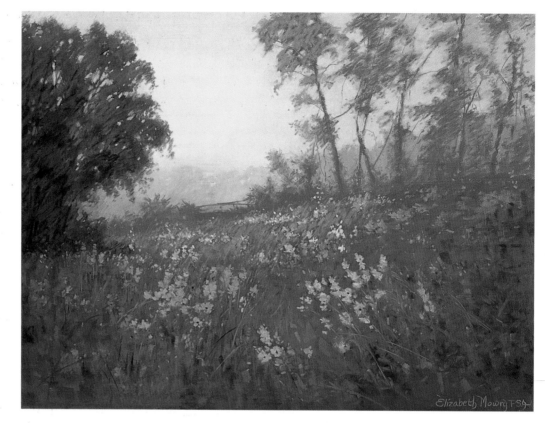

THE FIELD C
Pastel on mounted sanded paper,
18" × 24", 2001, collection of
Claudia and George Nekos

Within the same size and format of the two previous paintings, a shift to the left of the subject now includes the entire tree that had been only partially visible. This noticeably changes the sky shape and "opens up" the meadow.

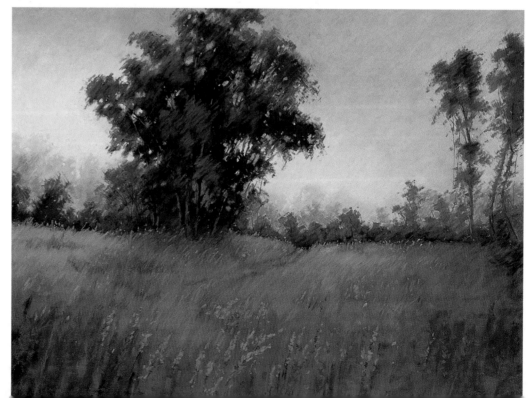

As the seasons passed and the weather changed, I painted the field over and over with a succession of layered moods. Summer arrived and passed quietly; Thanksgiving came, then snow; and a year later the wild phlox appeared again. I painted a final scene of the flowers as I turned and left the field and the icon of the trees behind. The series of field paintings was completed.

My subject matter of choice remains landscape. Nature was so much a part of my enchanting but singular childhood that the bond was a passionate one. I am comfortable with my motifs because for me they are what I truly know the most about. Even within a traditional venue, creative thinking can work its magic. For me, time alone and silence are indispensable to imparting my personal imprint on the landscape that I see. When passion for a place subsides, I quietly tend my garden for a while. It is a peaceful space where flowers and herbs have decided for themselves where they want to be, but it is, inexplicably, the place where my mind opens itself to the poignant presence of inspiration. Eventually, at the end of some late afternoon, I will catch a glimpse of the shadow of my muse, waiting patiently to guide me toward the edge of another beckoning landscape.

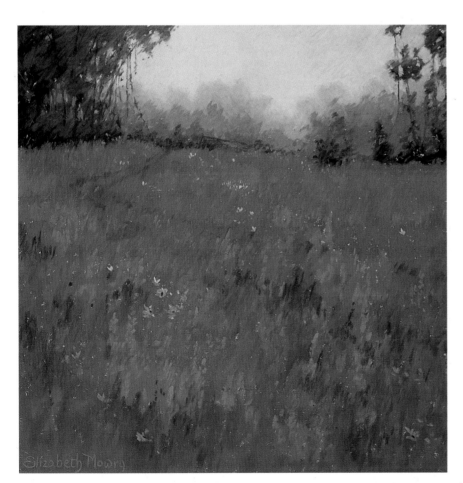

THE FIELD D
Pastel on sanded paper, 12" × 12", 2001, collection of Carol Meyer

Staying to the left and closing in on the previous view places the horizon line higher within a square format. Emphasis moves to the flowers, which have taken on brighter color but have diminished in variety and attention to shape. In this and the previous painting I had already become comfortable enough to have the loosestrife of later summer in mind as I worked.

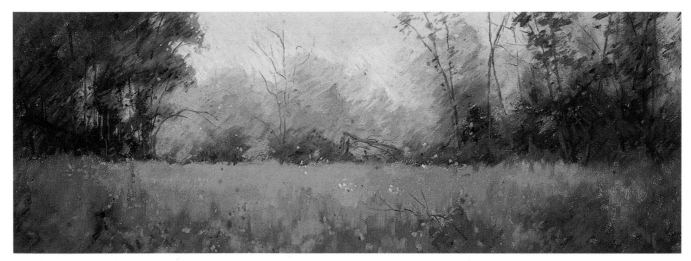

THE FIELD E
Pastel on sanded paper, 5 ½" × 15 ½", 2001, collection of Peter Booth

Zeroing in on a rectangular portion of the horizon line, I enjoyed my adventure with the warm analogous palette and "glazed" all of the landscape components with the rose glow of light.

THE FIELD F
Pastel on sanded paper, 5 ½" × 15 ½", 2001, collection of Duncan Sommerville

Within the same size and format of the previous painting, I backtracked my color exploration to a cooler palette and discovered an opportunity to play with the atmospheric perspective of some of the background shapes. Both of these explorations provided the opportunity to learn about color temperature and harmony within a painting.

THE FIELD G
Pastel on sanded paper, 12" × 16", 2001

The challenge here was to see if a warm sky would work credibly with delicate strokes and soft color use in the trees and grasses, or get lost in the realm of fantasy.

THE FIELD H
Pastel on sanded paper, 6 1/2" × 4 1/2", 2001, private collection

At this point, I realized that all of my paintings included these two embracing trees, spared by machinery, along the brush-covered stone wall that separated the field from another behind it. Meaning shifted from the initial attraction of the flowers to this portion of the subject, which emerged as the "icon" of the series . . . in my own mind, a reminder of compassion and hope.

left
THE FIELD I
Pastel on mounted sanded paper, 24" × 32", 2001

Moving from a tiny image to an expanded, more encompassing one, I simply experimented with a limited palette that was interesting to me. The size of the work is a tribute to taking risks in our work in order to discover possibilities. The best way to learn about color unity within a landscape is by trying to achieve it.

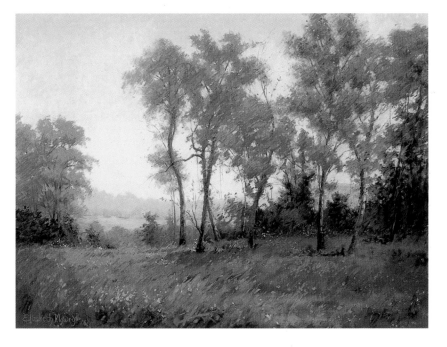

THE FIELD J
Pastel on sanded paper, 12" × 12", 2001,
collection of Joanne Sonshire

Spring's pink and white flowers began to be replaced by yellow. I zeroed in closer on the iconic area and investigated the idea of early morning light. The palette is simple, but unified by a delicate use of complements.

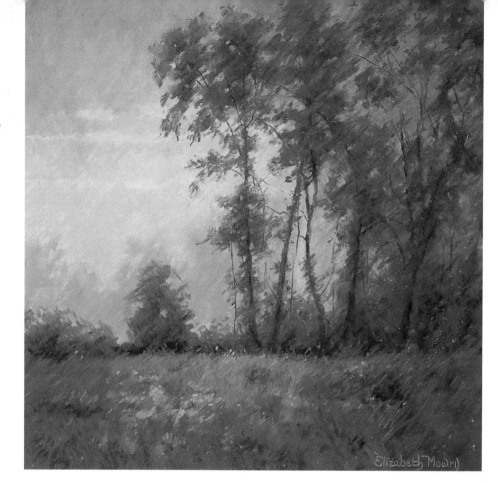

below
THE FIELD K
Pastel on sanded paper, 7" × 16", 2001

Overcast days present a landscape without the deep contrasts of sun and shadow. While the background may appear hazy, closer shapes frequently hold together with more strength than if the background were visible.

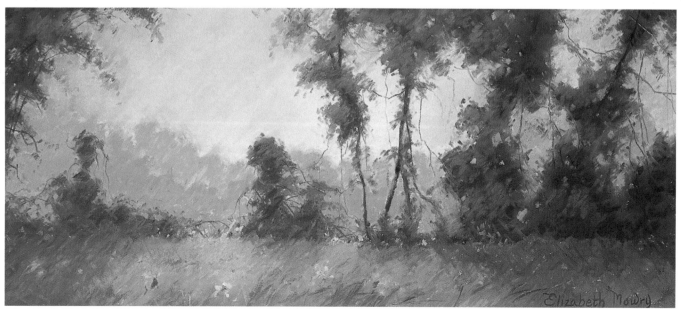

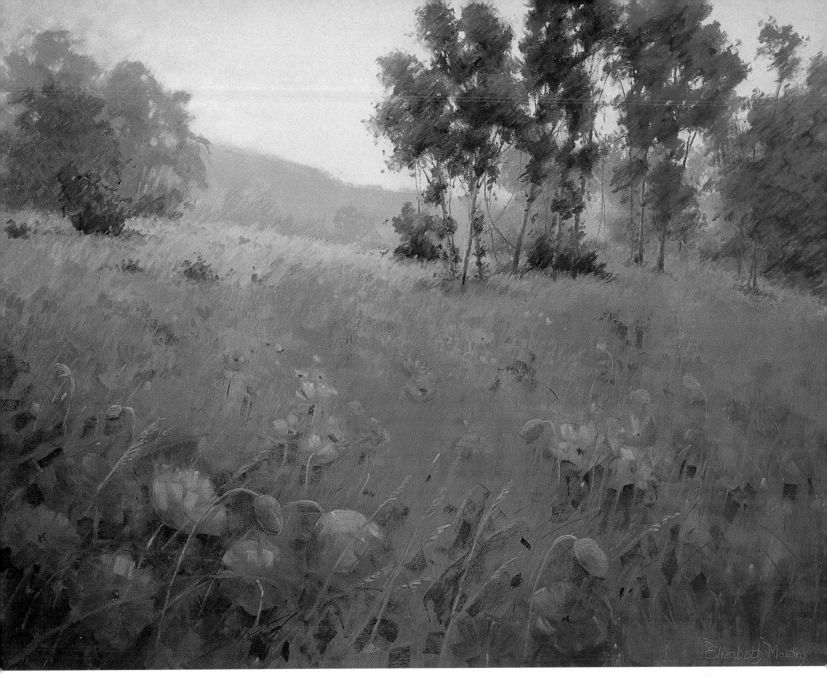

THE FIELD L
Pastel on mounted sanded paper, 18" × 24", 2001,
collection of Marie Vilagi

Keeping the haze of the former image, I expanded the view here, tipping the horizon to the right, and incorporating the grace of the complementary poppies.

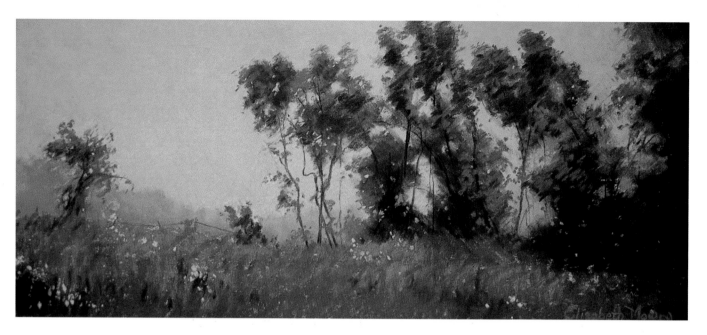

above

THE FIELD N
Pastel on sanded paper, 7" × 16", 2001

Back with the rectangular format, and again using an uncomplicated area of the subject as well as an uncomplicated palette, the painting becomes simply about the poetry of the tree shapes in dialogue with the sky.

right

THE FIELD O
Pastel on mounted sanded paper, 16" × 24", 2001, collection of Michelle Hancock

Late summer rain can drain the landscape of color. To paint subtle atmospheric conditions, it is necessary to pay close attention to minute value differences and, in most instances, decrease the intensity of color hue.

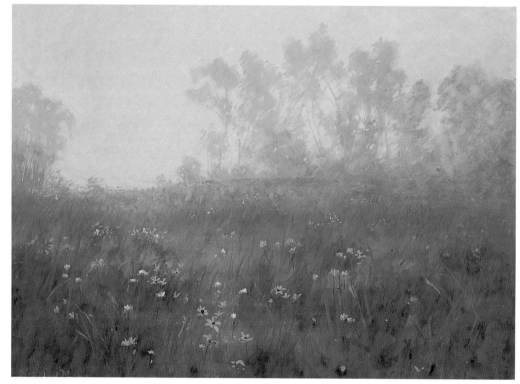

left
THE FIELD P
Pastel on sanded paper, 14 1/2" × 11", 2001,
collection of Andrew and Ingrid Novak

On a clear day, an intense blue sky works with the yellow grasses, which are also intense because the palette is minimal, consisting of blue, yellow, and warm and cool green (blue and yellow combined). Only a few flowers are suggested. Values are slightly closer to one another at the top of the painting, keeping the eye paused at the lightest area of blue.

below
THE FIELD Q
Pastel on sanded paper, 11" × 20", 2001

Now I take the yellow from the foreground up into the sky. The grasses are dry and the mood is somber. Part of the hill rolls off to the right, mysteriously quieting that side of the painting even more.

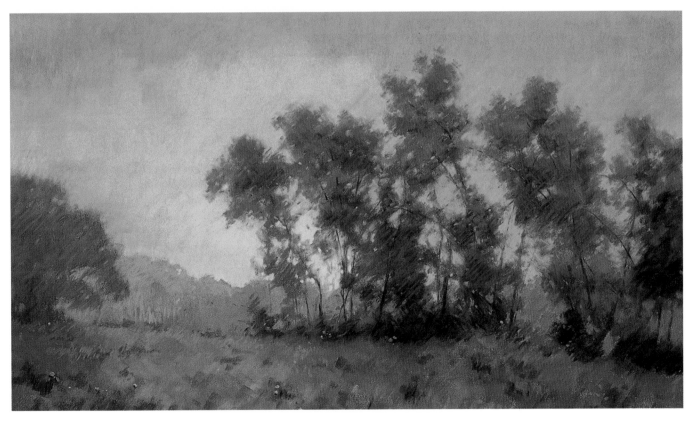

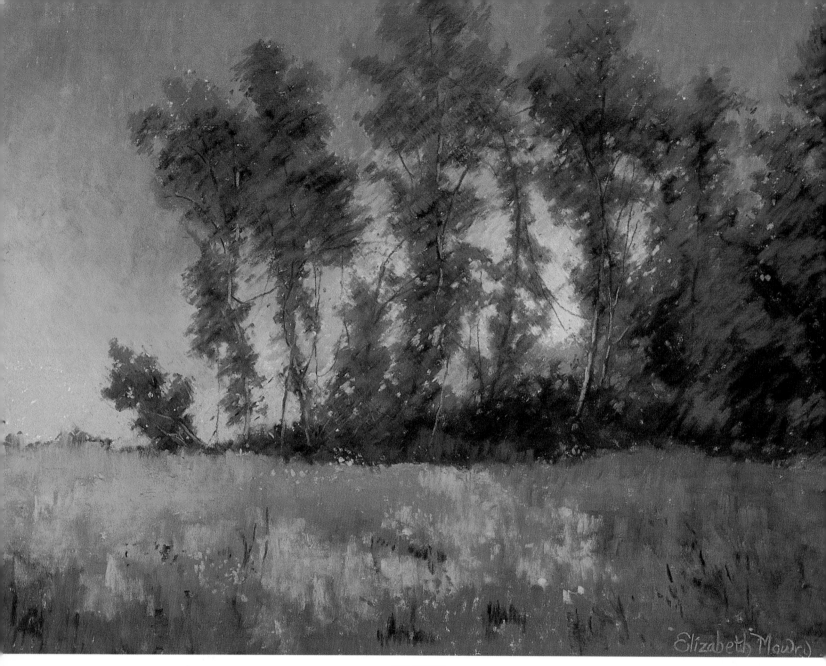

THE FIELD R
Pastel on sanded paper, 12" × 16", 2001, collection of Deborah and Craig Crump

This painting was done on Thanksgiving Day, 2001. It had something to do with the colors of harvest, the finality of yet another season, and a deep appreciation of nature and all that is good.

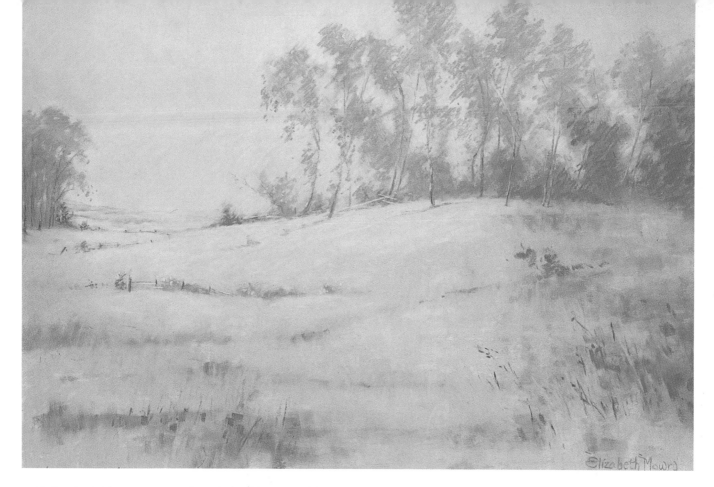

THE FIELD S
Pastel on mounted sanded paper, 16" × 22", 2001,
collection of Dan Feller

*Snow has drifted over the same field that held
a profusion of flowers earlier in the year. A low,
weak sun lights other fields beyond. The mood
as well as the palette is quiet and fragile.*

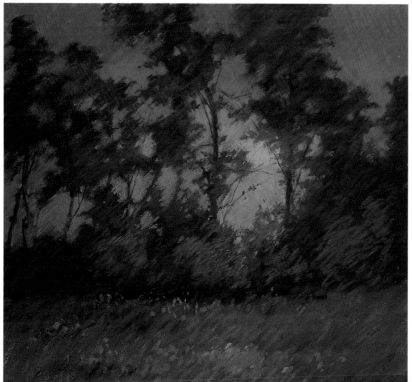

THE FIELD T
Pastel on sanded paper, 12" × 12", 2001,
collection of Jane and Don Bauer

*A new year is represented by the promise of hope
and light. Throughout the year the reasons for the
paintings have changed. With the familiarity of
a same-subject theme explored, more space became
available on the painting surface for emotion.*

THE FIELD V
Pastel on sanded paper, 15" × 20", 2002, private collection

By the time the wild phlox bloomed again the following spring, a full year later, I had tried many palettes, condensed and expanded the scope of the field in my paintings, and changed the times of the day and the weather as the seasons unfolded. I realized that now my muse was beckoning me to yet another place of mysterious challenge and new intrigue. I turned away from the icon of crossed trees and the open field, and this final image is what I saw as I left the magic behind.

Thoughts: Artist to Artist

THE FIELD series is an example of a motif that took shape the instant I saw the field. An intense momentum grew as I kept getting more ideas about what else I wanted to try with the concept. Once I became comfortable with the compositional elements of the scene, I placed my attention elsewhere . . . on choice of palette, format, seasonal changes, and finally on emotional content.

This is a rewarding way to work. First of all, the choice of subject is personal, so motivation is high. You begin, work, critique, sort out ideas, make choices, and then paint and critique again, and begin to compare. Alone with your own work, you can be objective and honest, taking as much time as you need to answer your own questions about what pleases you and what does not. What you are doing is creating your own lessons and challenges. Quickly you will see that you have favorite pieces; ask yourself, "Why?" Give some thought to what you might change in some of the others, and what you want to try next with the idea. The learning curve is extremely high and without penalty.

Some subject matter will present many painting possibilities, such as the field did for me. However, setting up expectations can be a pitfall here and a strain on creativity that may backfire. It is crucial that learning be the only goal. Only then will you feel the freedom to run with the idea and, equally important, know when to stop. Flexibility is the key. I believe that when another scene or subject begins persistently to fill your mind with intrigue, it is a sign that the theme you are presently working on needs to be concluded.

All artists eventually develop a preference for the way in which they work, and there are many. Painting in a solitary manner, obsessed with a motif that just might take over your life for a while, may not be for everyone. It is what works for me at this time, and I enjoy having a project wherein many areas of my life are interrelated.

At a time when most things have been analyzed extensively, creative thinking remains steeped in mystery. It is hailed and frowned upon, rewarded and discouraged, and by those who possess it, blessed and cursed within the same lifetime. The catchy contemporary phrase "outside of the box" is used to describe innovative work and ideas. A box constitutes limits that help form or conform; it represents convention. Where practicality and efficiency prevail, structure helps us to finish the list, meet expectations and goals, and stay on track. In the art world, however, boxed goods are noted but seldom rewarded. Artists are not required to deliver literal translations of the landscape. Its existence documents itself, and we must acknowledge that the photographer is better equipped for the task of recording reality, which liberates us, as artists, to paint our own impressions of the landscape we see. Kahlil Gibran (1883–1931) reminded us that "He alone is great who turns the voice of the wind into a song made sweeter by his own loving."

Exploration
of an Idea

Minimal Light Series

SOME ARTISTS wait for the afternoon sun to throw purple shadows over white fences, but I'll take a dawn shrouded in murky fog anytime, or those precious few minutes of dusk as the sky lets go of the final fragments of light that are still attached to the lower edges of the clouds. To experience the mystery of such fleeting moments in solitude is a gift. Nothing can prolong those dual windows of grace at the beginning and the end of each day, and unlike an exquisitely written passage that can be reread again and yet again, or an achingly beautiful refrain of music that can be played many times, within seconds they are gone. Always tomorrow's dawn will be different, and dusk cannot be predicted by the morning that precedes it.

VIOLET LIGHT
Pastel on pastel card, 4" × 6", 2000

This minimal study of a few interesting spaces among the trees creates a hushed dialogue between positive and negative shapes.

Fortunately, through the filtered sensitivity of the artist who selects such tenuous moments to paint, these gifts can be shared.

Beautifully executed paintings of minimal light hovering over a simple landscape awaken the beholder to a fresh awareness of the first and last moments of daylight anywhere. These layerings of colored mood serve as dogmas of serenity, and just as easily, expressions of sadness and melancholy. Although *seeing* is considered by many to be unteachable, by presenting a visual opportunity to experience quietude through nature's half-light on simple shapes, the artist offers a first step.

With nature as a genuine and unaffected partner in life and in work, an artist is apt to observe the refined subtleties of detail that others miss or take for granted. Including a low sun or an early moon in a landscape is something that either makes the painting memorable or ruins it. My fascination with the possibilities of this phenomenon continues. For now, what I am certain of is that when a sun or moon is actually painted into the landscape, it is most effective when the landscape consists of extremely simple shapes. I have painted skyscapes in the past without reference to land forms, and I have admired others that were extremely well done, but personally, I now prefer to see a noncompetitive relationship between the sky and the landscape beneath it, even if minimal. The task of the artist, though, is to get it right.

BECKONING I
Pastel on pastel card, 6" × 9", 2002, collection of M. and Mme. Jeanmaire

BECKONING II
Pastel on pastel card, 8" × 13 1/2", 2002

BECKONING III
Pastel on pastel card, 5" × 15", 2002

The subject of these pastels is the same sloping edge of a field near my home at slightly different times of the day. There is a valley between the trees and the background hills, and what continues to interest me is the varying degree of visibility of the line of tree shapes. In Beckoning V, on pages 124–125, familiarity with the subject made it possible to move beyond the obvious and to experiment with the shapes, with losing most edges but preserving those that were important, and with the idea of keeping a potentially aggressive palette quiet. Because I feel there are more painting ideas to explore here, I check out the scene whenever the fog sets in or the seasons change.

SANIBEL SUNSET
Pastel on panel, 5" × 12", 1997,
private collection

Most viewers would easily relate to this scene. When the artist becomes too enthusiastic about "setting fires in the sky," the painting reads as overdone and the onlooker cannot get beyond the color to the quiet beauty of the beach at this time of day.

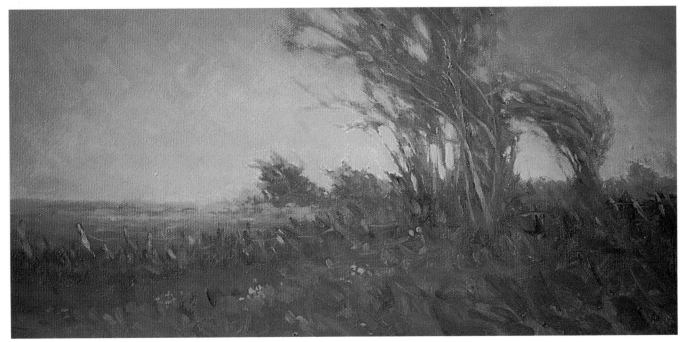

MANGO SKY
Oil on canvas, 8" × 16", 2003

This is the kind of sky that one would question until privileged by the experience of seeing it firsthand. Even so, opaque warm color is difficult to paint convincingly, and there is always the added tendency to brighten up the foreground too much.

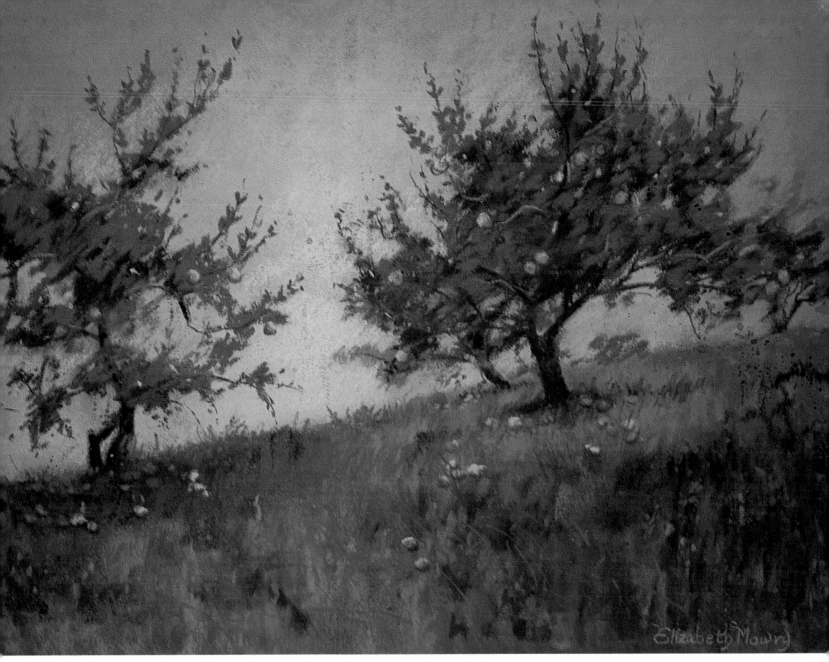

ORCHARD LIGHT
Pastel on panel, 12" × 16", 2000

While some people spend weekend mornings leisurely reading in bed and then begin aperitifs in late afternoon, other dubious characters mysteriously roam around with camera in hand at those times. The rewards are well worth the efforts and the eccentric reputation.

right
EARLY MOON, NEW PALTZ
Pastel on pastel card, 4" × 6", 2001

Here the moon appears in late afternoon and throws an eerie light over a landscape near my home. Complementary low-chroma color gives quiet strength to this simple subject.

below
THE TREE AND THE MOON
Pastel on sanded paper,
5¹⁄₂" × 12¹⁄₂", 2001

A monochromatic palette defines one tree rising from the horizontal landscape as the moon lights and balances the simple land forms. The scene is in New Zealand, but represents flatlands in many locations.

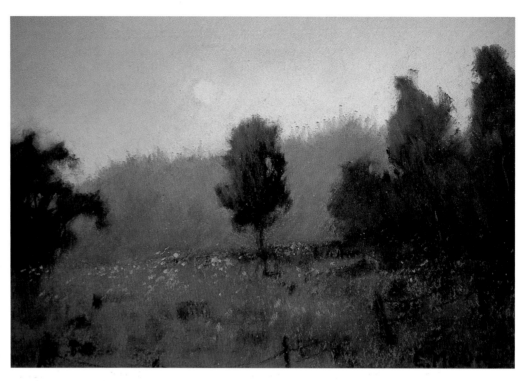

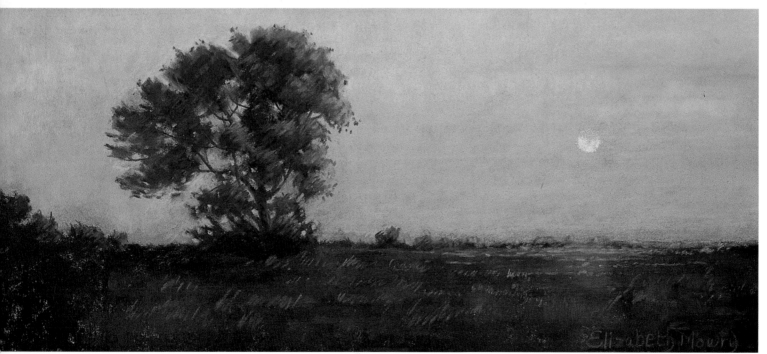

landscape meditations

130

Thoughts: Artist to Artist

DAWN and dusk are not generally plein air painting subject matter. At those times the light in the sky is changing more rapidly than at other hours in the day, and the most dramatic moments are the most fragile: early dawn and late dusk. Although it is possible to quickly sketch and make a few color notes, I often rely on my camera to provide the distinctions I need between the light and dark shapes at these tenuous times of the day. Also to be practically considered at dusk is how far into the woods or off the path you are when all the light will be gone. (It may just have been a lucky day for Hansel and Gretel.)

For the serious artist, dawn and dusk are best experienced alone. You need to be free to move about quickly with your camera without taking time for explanations. When you awaken in the morning and the sky is sublime or the fog is caressing the landscape, there is no time to be calling friends to arrange an outing or to be color coordinating the clothes you put on. Hesitation is not an option—opportunities that can make a huge difference between the exquisite and the ordinary will be lost in just those few minutes. It is the same at the end of the day. You never know when the color of the day's last light is going to make your heart skip a beat. Of course, if you happen to be driving on a freeway, common sense hopefully kicks in so that you keep your eyes on the road and forgo the photo in anticipation of another future opportunity. In my car, I always have a reliable, simple camera with extra film, a hat that reeks of insect repellent, and a pair of boots for mucking around in a dewy landscape at unheard-of times of the day when no one else would want to be with me anyway.

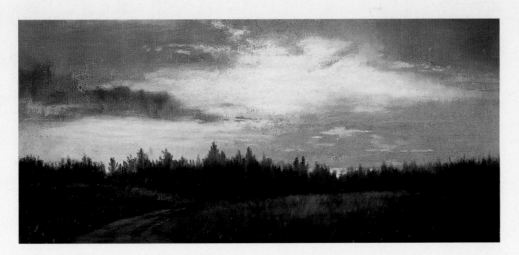

VALEDICTORY
Pastel on pastel card, 5" × 11", 2002

As I returned from a long walk through meadows behind my home one late November day I saw this spare, calming landscape. Melancholy is often a component of our past and future long-term perspective. Sometimes a light in the sky such as this has a way of melting it away when it lingers.

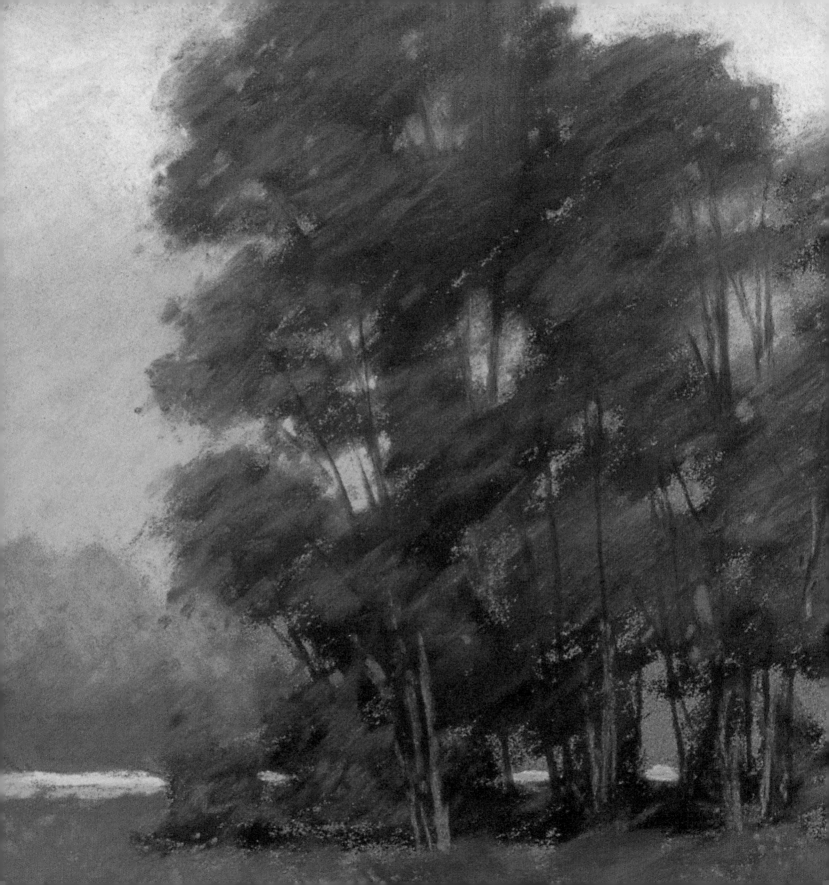

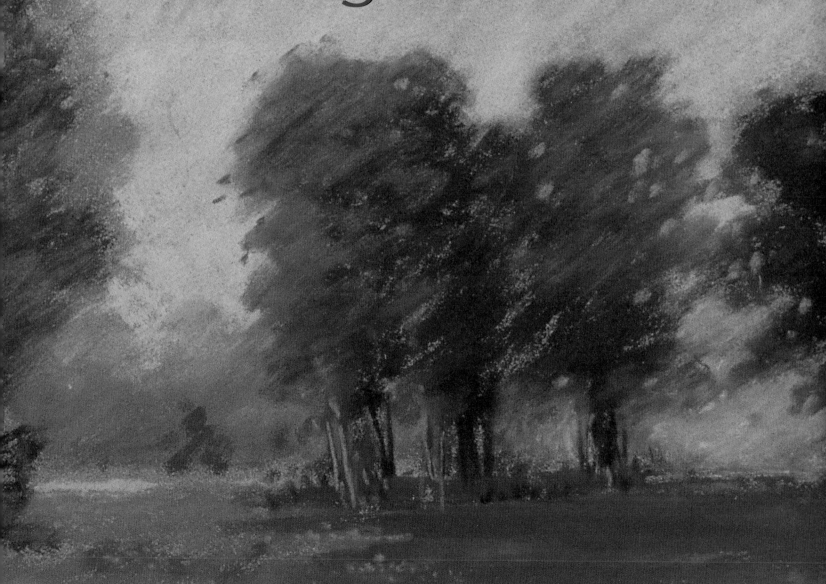

CHAPTER 8

Individualizing Our Painting Methods

The Minimal Impression

WHEN TIME at a painting location is limited by the clock or by daylight, yet longer than that required to take a few photographs, you might consider painting "minimal impressions": little landscape color patches of natural shapes. This is an enjoyable plein air alternative to hastily putting down a lot of information about a comprehensive subject and yet feeling as though no part of what you have done is resolved.

What has worked well for me has been to concentrate on only a very small but compelling part of the landscape, and then to find and attach *essence* to the idea of exactly what that is. I select a tiny area of sun playing in the shadows, the edge of the horizon where melting shapes hover, or a questioning glimpse of a river or a road and study it briefly, then turn away and try to retrieve the elusive memory with the least possible detail and see if it will hold together wordlessly. It is possible, sometimes, for memory to surpass the reality, and when it does, the little "color patches" become intimate expressions of ourselves.

Depending on what you are looking at, the *minimal* impression might consist of horizontal layerings of color, "weavings" of subtle values where edges disappear and reappear, juxtapositions of seductive line, or conversations between interesting shapes. Rather than an aggressive, ground-in application of pastel or paint, the diminished scope of what what you attempt lends itself to tenderly cautious strokes or brushmarks that "romance" the surface.

Try always to focus on only a tiny part of the landscape, and do not be afraid of "less." Surprisingly, when you succeed, the little images will very often represent the idea succinctly and without additional support. If a schedule change allows more time, you can work outward from what you already have, but if "the bell rings" or the light disappears, you already have something that pleases you.

I have kept some of my own minimal pastoral impressions visible in my studio, intending to use them as part of larger works. As time passes, I have grown to like many of them well enough just as they are.

Recording a single impression of some part of a larger landscape is really an exercise in scanning nature for a small seductive area that we deem worthy of further thought and effort. This in itself is beneficial because it requires us to choose less from more, and although we do not need to enumerate the reasons for any choice, they are there. By zeroing in on nature we are psychologically "cropping" down to a single statement, what we find so compelling that we cannot leave it alone. Then, as we work within those predetermined, self-imposed parameters, we learn whether we can restate what we see in an integrated way that will generate interest. If we cannot, we are obliged to reassess and then make changes or try alternative techniques. The advantage here is that on a small scale we are providing ourselves with opportunities to learn large lessons.

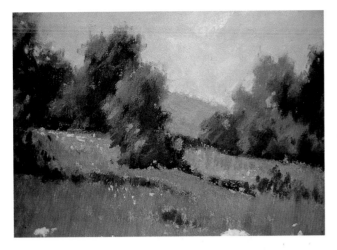

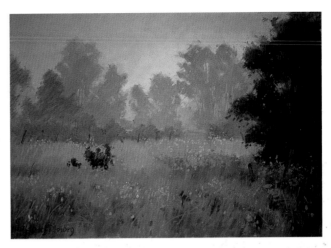

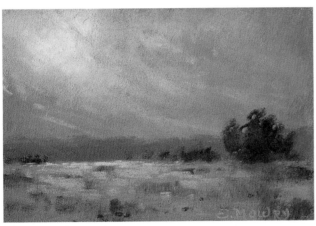

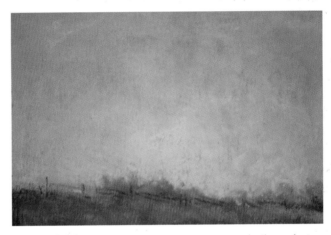

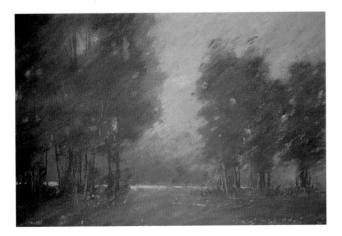

Here are some samples of painted minimal impressions, all unencumbered by titles because of what they are. All of them are smaller than four or five inches in any direction. Several have been used in larger landscapes; others have not.

Over the years, my keen interest in simplifying, shared with all of my students to a point of monotony (for them), has not subsided. As time passes and vision changes, I am preparing to work on a much larger scale. At the same time I intend to keep my subject small and uncomplicated. It will be yet another adventure. Change can be exciting when we are not afraid of it. It can be the challenging flip side of the stagnation that accompanies repetition. It can also be the positive spin on "turning the page" that keeps each future quest within view, so that the muse that once beckoned will beckon again.

Thoughts: Artist to Artist

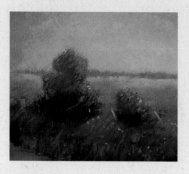

ARTISTS work differently from one another because we are all "wired" uniquely. Some people can step off the bus, choose a spot, place their vision on the painting surface with impeccable accuracy, and translate what they are looking at into a finished work that they are proud of. Currently, this is an immensely popular method of working. I remain in awe.

Throughout my twenty years as a landscape painting instructor, much of my time was spent painting en plein air. I really loved being outdoors, enjoying the full experience of natural light along with the fresh air, soft breezes, and birdsong. I rationalized the work I did outdoors as sketching or taking visual notes for larger work to be done in the studio.

What I began to realize, unfortunately, was that except for studio or classroom demonstrations, I did not actually use many of those hasty "sketches" for larger work at all. I eventually had to separate the joyful group experiences of being outdoors from the work I did there. Since then, and with painful honesty, I had to examine how and where I do my *best* work. The answer was—in my own studio. I needed to trust my own ideas and feelings about painting pure landforms creatively with confidence and away from reality.

The background facts had been in place for a long time. As an only child I spent much time alone and always did things with a high and sometimes dangerous level of intensity. I strove constantly to overcome imperfection and was never comfortable with unfinished tasks. Most of all, I absolutely hated repeating what had been done already (reality is already what it is); I also possessed an uncontrollable need to "improve" things. Since then, maturity has gently diminished the number of predictably disastrous life adventures, replacing them with an Emersonian philosophy that validates my working methods now, which depend more on intuition about what *could be* than on the plein air reality of *what is*.

I also had to come to terms with the gap between the talent I was given and the skills that I lack. Nature is what I know and love best. Painting it has become my subdued voice. I require a great deal of solitude in

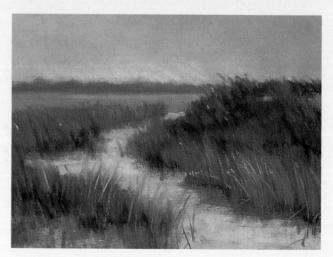

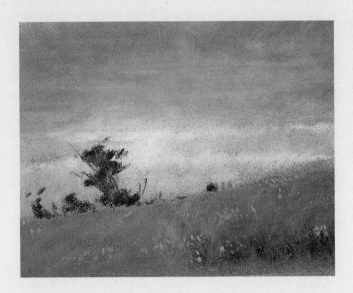

my life as well as in my work. Thinking about my purpose, sometimes for a long time and at other times hardly at all, is how I visualize what I hope to express with artistic honesty as I gently layer a personal meaning over the natural landscape that I paint.

I continue to photograph the landscape near my home and during my travels because the photographs are useful compositional references for beginning a painting. Sometimes even now, when conditions and time make it possible to sketch a small portion of what I see, I create another "minimal impression." Later I can evaluate whether or not to expand shapes around it or add a foreground that leads into it, to thoughtfully insert more detail, to leave it as is, or to toss it . . . all are valid.

In response to what I have learned over many years, I found that I have tailored a new way to enjoy working outdoors that has satisfied my yearning to learn, with results that are useful. Through these minimal impressions I have individualized my way of working outdoors to fit my search for the poetic. Now the sonnets and the epics are for others to record. I am growing content with painting haiku. And perhaps you would enjoy it, too.

The minimal impression has supported and sustained my intense interest in the expressiveness to be found in nature . . . an expressiveness that can match every characteristic human emotion and stage of growth. I am mesmerized by the human correlations with nature that follow elusive paths toward definitive conclusions. It is interesting to determine where or when in life we cross over that tenuous boundary between striving, pushing ahead, and fighting wars and debates and needing always to win the race and the prize, to where it is simply enough to create in cloistered silence some small painted memory of significant joy.

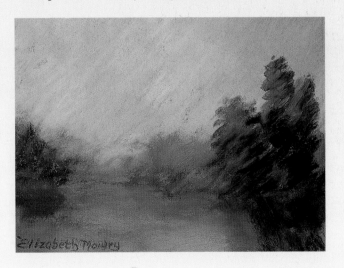

Condensing to or Expanding from a Focal Point

Series of Related Works

As we seek the answers to life's big questions, sometimes we are led toward the ultimate truth by what seems to be a convoluted path of coincidence. At other times, we intuitively begin with a truth, but we need to look outward to understand why it is so. Likewise, the direction we take as we begin a painting depends on our vision of the idea. For example, if the landscape filling our mind's eye is expansive, we may begin carefully placing the larger shapes and color relationships on the painting surface in a loose manner, after which we might tighten up or "pull out" what is most important or what we want to *make* important as our assessment deepens. On the other hand, if the image persistently crowding our mind is an intimate flicker of light and shadow that begs to spill its detail into the middle of our painting surface, we might honor that vision by setting it down with perfection, after which we can evaluate whether or not we wish to support that keen place of interest by working outward in any or all directions.

Yet another possibility would be to consider a same-subject, directional series exploration that could be approached by beginning with an overall impression, or, in reverse, by painting the center of interest first. Surprising abstract or realistic observations become obvious depending upon whether we provide the backdrop "stage" first and carve in toward the focal point, or work in reverse.

The first approach to a directional series of same-subject paintings, beginning with a painting of an overall scene that is appealing, requires immediately afterward that we ask ourselves what part of that image invites us to investigate more closely, and then gradually to zero in toward it in subsequent paintings. Generally what happens is that we paint a number of visually cropped images until the final painting *is* the focal point. It is possible that the nature of the paintings will change from realistic toward an abstract final image as supportive elements are removed. These serial paintings gently remind us of the "narrowing down to the essential" that is brought about over time by reflection in mature humans, and finally, by necessity, in the elderly. Each painting in the series is nevertheless important and able to stand on its own merit, just as each stage of life has its significance.

The other choice begins initially with a small detailed painting of a selected focal point. Most important here will be the placement on the surface. In subsequent paintings we would add more and more of the surrounding landscape in any or all directions outward in support of that focal point. In this case, the center of interest is the first painting. It may be a simple but eloquent abstract arrangement of light and shadow, a band of tilting color layers, or a single line of movement caught by an attentive eye. As more support is added around it, each painting encompasses an additional portion of the scene and becomes more realistic, much the same as the learning that occurs through meaningful life experiences brings priorities into focus. It has been said that "When artists return repeatedly to similar subjects, the aesthetic development of their work becomes more profoundly apparent."

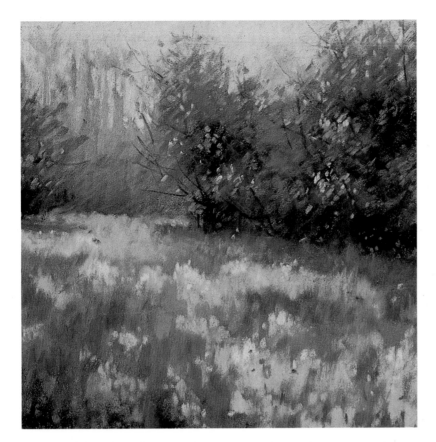

MUSTARD SEED IN THE ORCHARD
Four pastels on pastel card:
7" × 7" (left), 5" × 5" (bottom left),
3" × 3" (bottom center), and
1½" × 1½" (bottom right), 1997,
collection of Albert and Gudrun Novak

This series is an example of zeroing inward by visually cropping top, bottom, and both sides of the scene more and more. What remained in the final image was the small space to which the eye traveled in all of the work. By then the detail had disappeared, the color was subdued, and the subject was reduced to only the abstracted suggestion of natural color layers in the landscape.

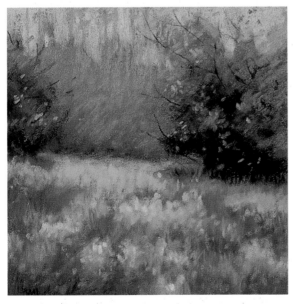

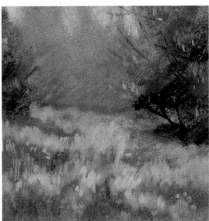

DIAGONALS D'AUNAY
Four pastels on pastel card:
7" × 7" (right), 5" × 5" (bottom left),
3" × 3" (bottom center), and
1¹/₂" × 1¹/₂" (bottom right), 1996

*Here another example of "more to less" plays
with the single idea of natural landscape
directional shapes. The composition is
delicately fragile. The warm light shown in
a distant field of grain is where the eye is
guided even in the first painting. In the
final painting, it assumes quiet dominance.
Life, beautiful as it may be, lets go of all
but the essential when making the final
transformation to a new beginning.*

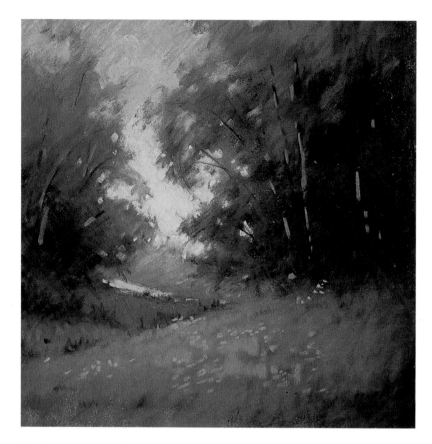

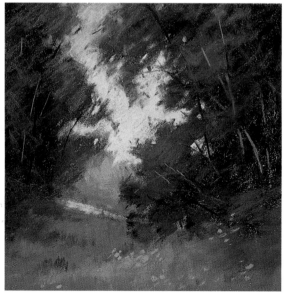

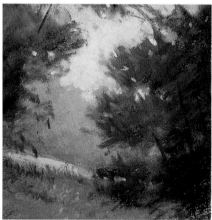

INVITATION
Five pastels on sanded paper: 1" × 2" (top left), 3" × 5" (top center), 5" × 7" (top right),
7" × 9" (bottom left), and 9" × 12" (bottom right), 1997, collection of Jennifer and Antony Hayward

In this series, I worked outward from the focal point. What first caught my attention was the sky space that was visible to the eye just before the turn in the road. Each successive expansion of the subject adds enhanced support to the first impression. All of the independent painting compositions exist without needing the others to be credible. Yet as a group they have more impact than any one alone. The subject is a walking road in Normandy in early summer.

condensing to or expanding from a focal point

EDGE OF A CORNFIELD
Four pastels on sanded paper:
9" × 12" (right), 7" × 9" (below left),
5" × 7" (below right top), and
3" × 5" (below right bottom), 1996

Quiet fields in Giverny are the subject here. They did not call out for attention; they simply were. A few trees divided the space. As I progressively cropped the subject, the idea of the single cedar tree began to emerge as a symbol of wistful longing by individuals who seek more than the obvious and find themselves on roads less traveled.

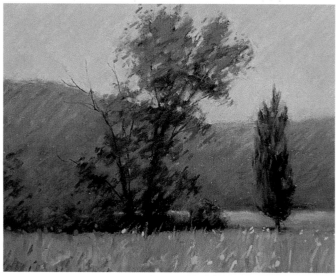

Thoughts: Artist to Artist

YOU CAN investigate landscape composition possibilities for a directional series with the zoom lens of your camera. Because of the nature of this type of series, for me, planning followed by thoughtful painting is best accomplished in the studio.

By doing four or five separate paintings of the same scene, altering only the scope, we are not merely adding or subtracting subject matter. Our work becomes more than an equal rendering of all parts. We learn about natural boundaries and what happens when we overstep them. We are constantly making evaluations about inclusion or exclusion of subject matter so that the gradual progression in the series surpasses repetition and moves seamlessly from one vision of the idea to another, with ultimate composure.

Henry David Thoreau reminded us that "We find only the world we look for." Nature already exists. Now, the question for the artist is, "What are *you* going to do with it?" The lesson in Richard Bach's *Jonathan Livingston Seagull* is a reminder that we need to "look, not only with our eyes, but with our understanding . . . to find out what we already know." It is not a mere exercise in hand movement; it is engagement of the mind. We must also remember that it would be foolhardy to work on a project like this with any reward in mind. I smile to myself each time I recall Katherine Hepburn saying that "to try to be fascinating puts us in an asinine position." Complacency is not an option, either. We have to be grateful for our own observations of the flaws in our work. And we must look for them, and learn from them. At the same time we must also be able to recognize when we have hit the mark and raised the bar. When the paintings are worthy, they will, with transparent clarity, find their own way to the reward.

Presentation example of a condensed or expanded small series. Occasionally you may want to exhibit a series of paintings together. Here is just one idea for presenting a small body of related works that vary in the sizes of their painted images. Notice that the frame sizes and the outside dimensions of the mats are consistent; it is the size of the mat openings that changes to fit the images.

Visual Narration in a Series

Veronica's Lace

A LANDSCAPE PAINTED by an artist who knows it well usually bears some degree of personal inscription. The very idea of painterly painting versus rendering a subject provides the viewer with a vision of nature as seen through the eyes of the artist. It is an invitation to reflect. For the artist, it may be a fluid shorthand or a reverent introspection. Although ordinarily I do not use landscape painting as a commentary, in this series of paintings my observations found their way into my work so poignantly that resistance was not an option.

VERONICA'S LACE 1
Pastel on mounted sanded paper, 24" × 30", 1998, collection of the artist

VERONICA'S LACE 2
Pastel on board, 16" × 20",
1999, collection of Kit and
Gordon Taylor

The works became a memoir, a source of solace, and a final gift honoring the person they were about.

Veronica's Lace 1 was painted for my mother, whose favorite wildflower was Queen Anne's Lace. She loved the painting. Shortly afterward, following a serious automobile accident, she spent her final fourteen months of life with me. During hours that she rested, I occasionally spent brief periods of time in my studio, and my next eight paintings, each one diminishing in size, pulled my mind back to the same compelling hillside where Queen Anne's Lace bloomed. Soon I began to realize that the significance of the work had much to do with letting go, in this case, of life. I watched as the extraneous peeled itself away, and my mother's concerns about things that previously mattered to her diminished. Her energy, and consequently her world, were closing in around only the essential. The scope of each consequent painting of *Veronica's Lace* diminished also with an unsteadying shift, finally zeroing in on the simplest few components, the slant of the hill at the horizon and the sky. Life has its own way of shutting down, condensing itself to the hour at hand. My mother's energy waned as did the light that hovered at the horizon in the landscapes that I painted. My final painting shows a fragile light lifting from the physical plane of the earth into the sky. My mother died the evening that an exhibition of this work in honor of her life opened.

VERONICA'S LACE 3
Pastel on board, 12" × 16", 1999, private collection

VERONICA'S LACE 4
Pastel on board, 10" × 12", 1999,
collection of Steve and Poppy Mills

bottom left
VERONICA'S LACE 5
Pastel on board, 9" × 11", 1999,
collection of Phyllis McCabe

bottom right
VERONICA'S LACE 6
Pastel on board, 6" × 8", 1999,
private collection

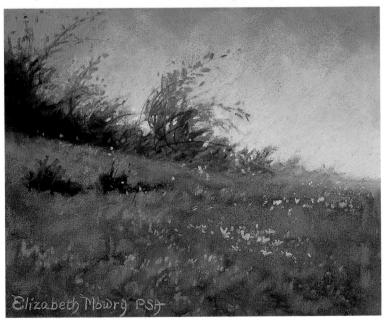

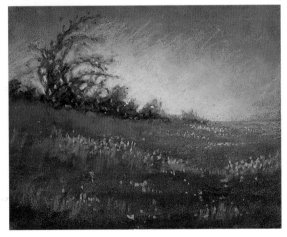

right
VERONICA'S LACE 7
Pastel on board, 5" × 7", 1999,
collection of Albert and Gudrun Novak

bottom left
VERONICA'S LACE 8
Pastel on board, 4" × 6", 1999,
collection of Dan Feller

bottom right
VERONICA'S LACE 9
Pastel on board, 3" × 5", 1999,
collection of Jennifer and Antony Hayward

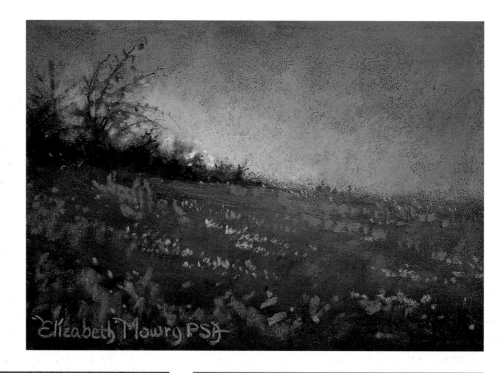

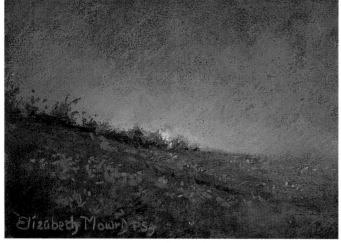

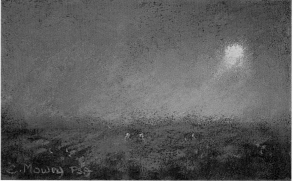

Thoughts: Artist to Artist

FOR ALL ARTISTS, there may be a few times during our lifetime when what we know best is the vehicle of expression we use to cope. It is when the muse takes us by the hand and paintings paint themselves. These are not experiences that we purposefully choreograph with an outcome in mind. Like spiritual meditations, they quietly envelope us and we do not need to know when or why. And afterward, we must carefully consider whether or not to share this work.

The nine paintings that evolved as *Veronica's Lace* are about closure, a gentle and mature coming together of the fragments of our youthful discovery and exuberance, and then later of our struggles to achieve and acquire, to feel power and then willingly to let it go

with grace and dignity as we begin to subtract priorities and lean into only the essential. Light, on the physical plane, gradually dims, then disappears as the spirit lifts up luminous and radiant to another place.

When emotions run high, I believe that artists need to be especially careful of extremes. Nature often requires a gentle soul to move the brush that paints it beautifully and honorably. The painfully graphic and sterile renderings as well as saccharine nostalgia or angry causes are well left to people who have closed those boxes around themselves and are comfortable inside of them. I have learned that it is possible to strive for freedom and grace in my paintings while still clinging to the fear of being out of control, but I choose not to use my work as a billboard for emotion. The cultivation of solitude paired with undercurrents of sweet melancholy are not qualities I intentionally paint into my landscapes. If it appears in the work, I can simply be grateful that my thoughts and my painted images run parallel.

Conclusion

MOST OF US POSSESS an inherent longing for related-ness and meaning. The process of staying with a landscape motif in painting is much like the unfolding of a flower to the sun, one petal at a time, until at full bloom it is a splendid sum of all related parts, whole in its beauty and purpose.

First we looked at a few of many theme paintings by artists in the past. Then within the previous ten chapters we considered general, broad-scoped subjects as well as specific directional departures. We have addressed the full investigation of a single place and deep exploration of one idea. We have seen how work accumulated over a long period of time may find its place within an ongoing theme. There were misty painting examples of the transient subject showing that some theme painting is possible only when specific conditions are present. Examples of the learning that is possible within a chosen motif were presented. Series painting using opposite approaches, namely movement from the supporting landscape inward to the center of interest, or expanding outward from the focal point, were shown. The ideas of anonymity and progression in degree within a motif were addressed as well, and finally the delicate appro-priateness of story was shared. The interlining abstract in all of the chapters was thoughtful inquiry into when and whether a subject is worthy of being painted.

When I was in college over a half century ago, a national English fraternity published a piece I had written that made reference to art and science as opposite and independent of one another, and no one challenged the piece. Unfortunately, at the time I was equipped with only limited life experience paired with as little knowledge. That youthful ignorance so singu-larly rooted in passion has long been tempered by a poignant awareness that art and science are not either/or institutions. It is reassuring now to know that wisdom and tolerance will wait for the right time to claim their space in our minds; that is when we are able to understand the beauty and integrity of complexity. Science is about investigation; it is about exploration of new ideas; and it is about finding answers. Art is about innovative concepts as well as new approaches to existing ideas, and also about finding answers. The questions may be different, but the best of art or science will always include the other. In his books, Alan Lightman, a physicist and novelist who teaches at Massachusetts Institute of Technology, touches on this fascinating subject in a readable way. Applied to landscape painting, intentionally or not, the strongest compositions are based on elements of abstraction in design and a strong sense of order.

As we begin to understand ourselves, we find where we fit in the world and the time in which we live. Our work gradually begins to reflect the philos-ophy we piece together and embrace based on the outcome of our life experiences, and on our invest-ment in studying what interests us emotionally, physically, and spiritually. According to Plato, "We become what we contemplate."

Inness admired the "inspirational power" of Corot. This same characteristic can be found in his own later work. Inness' paintings took on a theological dimension after his exposure to Swedish scientific writings about the relationships between the natural and the divine. In later life Inness found ways to translate his own beliefs about what might be possible rather than actual, and his work began to exhibit a heightened sense of order and arrangement. This was thought to be motivated by Emanuel Swedenborg's *Doctrine of Forms*, which showed how geometric forms in nature, from the simplest to the most complex, possess spiritual and even psychological properties.

There is so much to learn from nature about beginnings and endings, and about quiet joy and the steadfast continuity that prevails despite tumultuous underpinnings of variation as we witness the daily progression from morning to evening and then to morning again.

Landscape painting may be more important than ever now, when its subject is so threatened.

What *is* obsolete today is not only repetition over and over of what has already been done, but also the idea that the shockingly new, no matter how poorly executed or insipid, is the only criteria for what is good. Even within the traditional genre of landscape painting, we strive toward distinction through thoughtful exploration of subject. Answers will be revealed if we are honest in our inquiry, embrace the risks that need to be taken, and are willing to abandon other motives. Through the pairing of scientific inquiry with artistic passion, it is possible for intervals in our lives, spaces in our minds, and places we love to merge and evolve as meditations on the painted surface. Nature presents us with a scientifically beautiful sense of order that, when embraced by creative lyricism and expressed with excellence, becomes a powerfully quiet statement about what was, still is, and if we are careful, will be.

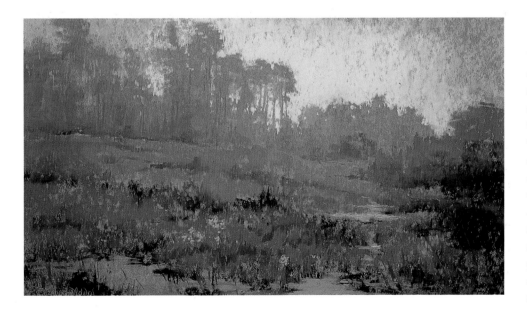

UNFINISHED ANDANTE
Pastel on sanded paper, 14" × 24", 2003

This is an example of a one-hour, end-of-the-day painting done in the studio in winter from a photograph that was used only for compositional reference. It was still unfinished when the music stopped and the light was gone. Although much of the painting surface shows, the melody of rhythms is already there. For me, there is an almost magical significance attached to paintings that evolve in this way. I open my mind to new directions that begin to claim space in my ever-unfolding curriculum.

My Painting Process

THE COLLECTION of theme paintings included within the chapters of this book are ideas in progress, some more resolved than others, by this painter who is still seeking, changing, shifting . . . always questioning, ever learning. Some are oil paintings on paper or canvas; most are pastels. At the moment, they are my best, but hopefully those yet unpainted will surpass, again and yet again, as it should be. Summarized here are some personal insights (subject to change) that may be helpful as you consider theme-inspired landscape painting.

ASSIMILATE

I habitually collect material such as informational articles and my own photographs about topics that I find aesthetically pleasing, and that I want to know more about. I look for similarities, links, cause and effect, different approaches to similar outcomes, or related approaches to different outcomes. The quality of my work is higher when I begin with a larger pool of information-based visualization as opposed to starting too soon before ideas are concrete and rich in content.

SELECT

I choose the one concept that is most interesting to me *right now*. As objectively as possible, I assess my skills for expressing the concept as I visualize it. Is it a worthy subject? I give serious thought to *why* I am making the choice, because the answer will keep me motivated and on track. A simple idea can be more interesting than complication.

CONDENSE

I consider *what specifically* I wish to address within the general theme, and how far I believe I can take the idea. Is the answer enough reason to abandon all other ideas, or would it be prudent to backtrack and make a different selection? Often a general topic such as wildflowers can be separated into categories: those of a specific geographic location, those that bloom during a particular season, those that prefer either wet or arid soil, or those having a specific shape or color. Condensing the subject makes room for arrangement, color, contrast, and movement to play a more decisive role in the outcome of the work.

DEFINE AND REFINE

I momentarily review the difference between "simple" and "simplistic" and then give the selected idea space in my mind to expand. I steer the course. I will be thinking now about format, size (intentionally consistent or varied), color combinations, or techniques I want to try. I make my lessons and then try to learn from them what I want to know. Seldom do I paint reality as it appears, so I need time to reflect upon *what I want to do with it*. It is like selecting the tempo of the dance.

START

I consider my passage "from here to there." Sometimes the path is short-term . . . day-to-day or now until an hour from now; sometimes it becomes the long-term pursuit of a vision. I address procrastination if it

becomes necessary by making an appointment with myself and my idea and staying there for a while. I go where there is no access to me. (When I was in college, I would sit in the local cemetery—leaning against a favorite gravestone—to compose my writing course assignments!) I have learned to empty my mind and then begin with the obvious, which is the *only* place to begin.

EXPLORE

During the last years of his life, George Inness strove only to "awaken an emotion" in his viewers, using the inner workings of nature as his subject. After painting the obvious, I can go wherever and everywhere with my theme, but I keep each idea separate, meaning one for each painting. There is no limit at this point. With the passion of Zorba the Greek, I go for it. What if it was raining? What if it was an hour later? What if it was foggy? frosty? winter? dawn? windy? Or dark with only a sliver of the moon lighting the sky? This is an exciting time! It is permissible to leave the "box" in shambles as one races over the landscape hand in hand with one's muse.

FOCUS

At this stage, I treat my project as a visual dissertation of *place* or of an *idea*. I am learning more about the subject I have chosen through my paintings. I am the captain of my ship. I concentrate upon the single idea that is unfolding on my painting surface. I believe, and follow through. As a landscape artist I know that technical expertise alone is becoming less the show-stopper; it is also exceedingly tiring to do, and tiring to look at afterward. I believe that emotion alone,

whether it appears in work that is saccharine, angry, frustrated, or just so ambiguous that there is no area of resolve, is boring as well.

CONCLUDE

I conclude when the excitement and joy subside. I know when I am there because my mind is easily distracted. It is time to select another topic, or let one choose me. Life consists of cycles. We paint more in some than in others, but all have much to do with the work that follows. I have been known to lament that there is never enough time to paint, but if I actively pushed my brush every waking hour of the day, would I like my work better? Would I like it at all? When I think about and visualize my subject at least twice as much time as I apply the medium, I am generally more pleased with my paintings.

WINTERSET SPRUCE (DETAIL)
Mixed media, 24" × 16", 1992, private collection

Sometimes an idea expressed in the past lies dormant for a while and then surfaces again as an epiphany for current acknowledgment on new painting surfaces. Life experiences continually supply us with changing energy and perspectives.

Ending Thought

ALL . . . EVERY BIT . . . of my life, every spell of happiness, every small discovery, every heart-wrenching disappointment, every honor, every unfairness, every step . . . forward, backward, to the side, off the path . . . has brought me to where I am now.

There were no shortcuts; there was not a better way, nor wiser decisions to be made. What was, was.

If anywhere along the path regret might have changed my course, only the views would have been different and the timing altered.

Like a leaf adrift in the autumn breeze, I would have been ultimately directed through all the lessons I needed, and sooner or later, and it matters not which, I would rest here in the calm of this moment.

STONE RIDGE FIELD
Oil on canvas, 24" × 36", 2004

Recently a friend who is known for his excruciatingly beautiful poetry wished me "eloquence at my canvas." Grateful, I wonder if my ongoing quest for "more with less" will evolve in time as "Silence in Landscape Painting," a haunting idea that has firmly worked its way into my thoughts and waits only to find its expression through my brush.

Bibliography

Rose, Francesca, ed. *Side by Side* exhibition catalog. Giverny: Musée d'Art Americain, 2003.

Bach, Richard. *Jonathan Livingston Seagull.* New York: Avon, 1973.

Bell, Adrienne Baxter. "George Inness and the Visionary Perspective." *American Art Review*, October 2003: 178–183.

Carlson, John S. *Carlson's Guide to Landscape Painting.* New York: Sterling Publishing Co., 1958.

Crowe, Sylvia and Mary Mitchell. *The Pattern of Landscape.* Chichester, England: Packard Publishing Ltd, 1988.

Ferrua, Gérard and Raphaël Merindol. *Marius Breuil: Paysagiste Provençal.* Avignon: Editions Barthélemy, 2000. http://www.marius-breuil.com

Keller, Deane K. *Draftsman's Handbook,* 2002.

Lightman, Alan. *Reunion.* New York: Pantheon, 2003.

Meier, Eleanor. In: The Catherine Lorillard Wolfe Art Club Newsletter, January 2003.

Moore, Thomas. *Meditations.* New York: HarperCollins Publishers, 1940.

Stebbins, Theodore E., Jr. *Martin Johnson Heade.* Boston: Museum of Fine Arts, Boston, 1999.

Suzuki, Shunrya. *Zen Mind, Beginner's Mind.* New York and Tokyo: Weatherhill, 1984.

Tinterow, Gary, Michael Pantazzi, and Vincent Pomarede. *Corot.* New York: Metropolitan Museum of Art, 1996.

Tucker, Paul Hayes. *Monet in the 90's: The Series Paintings.* Boston: Museum of Fine Arts, 1989.

Werner, Alfred. *Inness Landscapes.* New York: Watson-Guptill Publications, 1973.

Leigh, William R. *African Landscapes.* New York: Gerald Peters Gallery, 1998.

Art and Photo Credits

Page 5: Phyllis McCabe

Page 13: *A Road by the Water.* Photograph ©2003 Clark Art Institute. All rights reserved. Sterling and Francine Clark Art Institute, Williamstown, Massachusetts, USA.

Page 14: *Morning— the Cow Herder.* Photo: Herve Lewandowski. Musée d'Orsay, Paris, France. Photo Credit: Réunion des Musées Nationaux/Art Resource, New York.

Page 15: *Washerwomen in a Willow Grove.* Photograph ©2003 Clark Art Institute. All rights reserved. Sterling and Francine Clark Art Institute, Williamstown, Massachusetts, USA.

Page 16: *Newburyport Meadows.* Photograph ©1996 The Metropolitan Museum of Art. Purchase, Mrs. Samuel P. Reed Gift, Morris K. Jesup Fund, Maria DeWitt Jesup Fund, John Osgood and Elizabeth Amis Cameron Blanchard Memorial Fund and Gifts of Robert E. Tod and William Gedney Bunce, by exchange, 1985.

Page 17: *Sunrise on the Marshes.* Gift of Mr. and Mrs. William L. Richards through the Bray Charitable Trust.

Page 17: *The Great Swamp.* Gift of Mr. and Mrs. John D. Rockefeller 3rd.

Page 18: *Sunset Glow.* Photo Courtesy of the Montclair Art Museum, Montclair, New Jersey. Gift of Mrs. Francis M. Weld.

Page 19: *Winter Moonlight (Christmas Eve).* Photo Courtesy of the Montclair Art Museum, Montclair, New Jersey. Museum purchase, Lang Acquisition Fund.

Page 20: *Early Autumn, Montclair.* Special Purchase Fund, Friends of Art, 1965.

Page 21: *Home at Montclair.* Photograph ©1988 Clark Art Institute. All rights reserved. Sterling and Francine Clark Art Institute, Williamstown, Massachusetts, USA.

Page 22: *Bouquet d'Arbres.* Courtesy of Gérard and Paule Ferrua.

Page 23: *Les Deux Arbres.* Courtesy of Gérard and Paule Ferrua.

Page 24: *Dans la Plaine des Angles.* Courtesy of Gérard and Paule Ferrua.

Page 25: *Cloud Formations.* Courtesy of Gerald Peters Gallery.

Page 26: *Full Moon at Late Twilight on the Plains of Tanganyika.* Courtesy of Gerald Peters Gallery.

Pages 26–27: *Study for Wild Dog Group I, II, III.* Courtesy of Gerald Peters Gallery.

Page 27: *Sunset on the Athi Plains.* Courtesy of Gerald Peters Gallery.

Index